China's Design Revolution

Design Thinking, Design Theory
Ken Friedman and Erik Stolterman, editors

Design Things,
A. Telier (Thomas Binder, Pelle Ehn, Giorgio De Michelis, Giulio Jacucci, Per Linde, and Ina Wagner), 2011

China's Design Revolution,
Lorraine Justice, 2012

China's Design Revolution

Lorraine Justice
foreword by Xin Xiangyang

The MIT Press
Cambridge, Massachusetts
London, England

MIT Press books may be purchased at special quantity discounts for business or sales promotional use. For information, please email special_sales@mitpress.mit.edu or write to Special Sales Department, The MIT Press, 55 Hayward Street, Cambridge, MA 02142.

This book was set in Stone Sans and Stone Serif by Graphic Composition, Inc. Printed and bound in the United States of America.

Library of Congress Cataloging-in-Publication Data

Justice, Lorraine, 1955–
China's design revolution / Lorraine Justice ; foreword by Xin Xiangyang.
 p. cm. — (Design thinking, design theory)
Includes bibliographical references and index.
ISBN 978-0-262-01742-8 (hardcover : alk. paper) 1. Design—Social aspects—China—History—21st century. 2. Design—Economic aspects—China—History—21st century. 3. Youth—Social aspects—China. 4. Youth—Economic aspects—China. I. Title.
NK1483.A1J87 2012
745.40951'09051—dc23
 2011038981

10 9 8 7 6 5 4 3 2 1

To Steve and Alexa, who took the journey East with me

Contents

Series Foreword

As professions go, design is relatively young. The practice of design predates professions. In fact, the practice of design—making things to serve a useful goal, making tools—predates the human race. Making tools is one of the attributes that made us human in the first place.

Design, in the most generic sense of the word, began over 2.5 million years ago when *Homo habilis* manufactured the first tools. Human beings were designing well before we began to walk upright. Four hundred thousand years ago, we began to manufacture spears. By forty thousand years ago, we had moved up to specialized tools.

Urban design and architecture came along ten thousand years ago in Mesopotamia. Interior architecture and furniture design probably emerged with them. It was another five thousand years before graphic design and typography got their start in Sumeria with the development of cuneiform. After that, things picked up speed.

All goods and services are designed. The urge to design—to consider a situation, imagine a better situation, and act to create that improved situation—goes back to our prehuman ancestors. Making tools helped us to become what we are; design, in other words, helped to make us human.

Today the word *design* means many things. The common factor linking them is service: designers are engaged in a service profession in which the results of their work meet human needs.

Design is first of all a process. The word *design* entered the English language in the 1500s as a verb, with the first written citation of the verb dating to the year 1548. *Merriam-Webster's Collegiate Dictionary* defines the verb *design* as "to conceive and plan out in the mind; to have as a specific purpose; to devise for a specific function or end." Related to these is the act of drawing, with an emphasis on the nature of the drawing as a plan or

map, as well as "to draw plans for; to create, fashion, execute or construct according to plan."

Half a century later, the word began to be used as a noun, with the first cited use of the noun *design* occurring in 1588. *Merriam-Webster's* defines the noun as "a particular purpose held in view by an individual or group; deliberate, purposive planning; a mental project or scheme in which means to an end are laid down." Here too purpose and planning toward desired outcomes are central. Among these are "a preliminary sketch or outline showing the main features of something to be executed; an underlying scheme that governs functioning, developing or unfolding; a plan or protocol for carrying out or accomplishing something; the arrangement of elements or details in a product or work of art." Today we design large, complex processes, systems, and services, and we design organizations and structures to produce them. Design has changed considerably since our remote ancestors made the first stone tools.

At a highly abstract level, Herbert Simon's definition covers nearly all imaginable instances of design. To design, Simon writes, is to "[devise] courses of action aimed at changing existing situations into preferred ones."[1]. Design, properly defined, is the entire process across the full range of domains required for any given outcome.

But the design process is always more than a general, abstract way of working. Design takes concrete form in the work of the service professions that meet human needs, a broad range of making and planning disciplines: industrial design, graphic design, textile design, furniture design, information design, process design, product design, interaction design, transportation design, educational design, systems design, urban design, design leadership, and design management, as well as architecture, engineering, information technology, and computer science.

These fields focus on different subjects and objects. They have distinct traditions, methods, and vocabularies, used and put into practice by distinct and often dissimilar professional groups. Although the traditions dividing these groups are distinct, common boundaries sometimes form a border. When this happens, they serve as meeting points where common concerns build bridges. Today ten challenges uniting the design professions form such a set of common concerns. Three performance challenges, four substantive challenges, and three contextual challenges bind the design disciplines and professions together as a common field. The

performance challenges arise because all design professions do these three things:

1. Act on the physical world.
2. Address human needs.
3. Generate the built environment.

In the past, these common attributes were not sufficient to transcend the boundaries of tradition. Today, objective changes in the larger world give rise to four substantive challenges that are driving convergence in design practice and research:

1. Increasingly ambiguous boundaries among artifacts, structure, and process
2. Increasingly large-scale social, economic, and industrial frames
3. An increasingly complex environment of needs, requirements, and constraints
4. Information content that often exceeds the value of physical substance

These challenges require new frameworks of theory and research to address contemporary problem areas while solving specific cases and problems. In professional design practice, we often find that solving design problems requires interdisciplinary teams with a transdisciplinary focus. Fifty years ago, a sole practitioner and an assistant or two might have solved most design problems; today we need groups of people with skills across several disciplines and the additional skills that enable professionals to work with, listen to, and learn from each other as they solve problems.

Three contextual challenges define the nature of many design problems today:

1. A complex environment in which many projects or products cross the boundaries of several organization, stakeholder, producer, and user groups
2. Projects or products that must meet the expectations of many organizations, stakeholders, producers, and users
3. Demands at every level of production, distribution, reception, and control

Many design problems function at a simpler level; nevertheless, these issues affect many of the major design problems that challenge us, and these

challenges also affect simple design problems linked to complex social, mechanical, or technical systems.

These ten challenges require a qualitatively different approach to professional design practice than was the case in earlier times. Past environments were simpler, and they made simpler demands. Individual experience and personal development were sufficient for depth and substance in professional practice. Experience and development are still necessary, but they are no longer sufficient. Most of today's design challenges require analytical and synthetic planning skills that cannot be developed through practice alone.

Professional design practice today requires advanced knowledge, and not solely a higher level of professional practice. It is also a qualitatively different form of professional practice that emerges in response to the demands of the information society and the knowledge economy to which it gives rise.

In a recent essay ("Why Design Education Must Change," *Core77*, November 26, 2010), Donald Norman challenges the premises and practices of the design profession. In the past, designers operated on the belief that talent and a willingness to jump into problems with both feet gives them an edge in solving problems. Norman writes:

In the early days of industrial design, the work was primarily focused upon physical products. Today, however, designers work on organizational structure and social problems, on interaction, service, and experience design. Many problems involve complex social and political issues. As a result, designers have become applied behavioral scientists, but they are woefully undereducated for the task. Designers often fail to understand the complexity of the issues and the depth of knowledge already known. They claim that fresh eyes can produce novel solutions, but then they wonder why these solutions are seldom implemented, or if implemented, why they fail. Fresh eyes can indeed produce insightful results, but the eyes must also be educated and knowledgeable. Designers often lack the requisite understanding. Design schools do not train students about these complex issues, about the interlocking complexities of human and social behavior, about the behavioral sciences, technology, and business. There is little or no training in science, the scientific method, and experimental design.[2]

This is not industrial design in the sense of designing products but industry-related design, design as thought and action for solving problems and imagining new futures. This new MIT Press series of books, Design

Thinking, Design Theory, emphasizes strategic design to create value through innovative products and services, and it emphasizes design as service through rigorous creativity, critical inquiry, and an ethics of respectful design. This rests on a sense of understanding, empathy, and appreciation for people, nature, and the world we shape through design. Our goal as editors is to develop a series of vital conversations that help designers and researchers to serve business, industry, and the public sector for positive social and economic outcomes.

We will present books that bring a new sense of inquiry to the design, helping to shape a more reflective and stable design discipline able to support a stronger profession grounded in empirical research, generative concepts, and the solid theory that gives rise to what W. Edwards Deming described as profound knowledge.[3] For Deming, a physicist, engineer, and designer, profound knowledge comprises systems thinking and the understanding of processes embedded in systems; an understanding of variation and the tools we need to understand variation; a theory of knowledge; and a foundation in human psychology. This is the beginning of deep design—the union of deep practice with robust intellectual inquiry.

A series on design thinking and theory faces the same challenges that we face as a profession. On one level, design is a general human process that we use to understand and shape our world. Nevertheless, we cannot address this process or the world in its general, abstract form. Rather, we meet the challenges of design by addressing problems or ideas in a specific situated context. The challenges we face as designers today are as diverse as the problems clients bring us. We are involved in design for economic anchors, economic continuity, and economic growth. We design for urban needs and rural needs, for social development and creative communities. We are involved with environmental sustainability and economic policy, agriculture competitive crafts for export, competitive products and brands for microenterprises, developing new products for bottom-of-pyramid markets, and redeveloping old products for mature or wealthy markets. Within the framework of design, we are also challenged to design for extreme situations; for biotech, nanotech, and new materials; and design for social business; as well as conceptual challenges for worlds that do not yet exist, such as the world beyond the Kurzweil singularity—and for new visions of the world that does exist.

The Design Thinking, Design Theory series from the MIT Press will explore these issues and more—meeting them, examining them, and helping designers to address them.

Join us in this journey.

Ken Friedman

Erik Stolterman

Editors, Design Thinking, Design Theory Series

Foreword

China, despite its entrenched communist system and long-standing traditions, has reinvented itself during the last thirty years from a closed political entity to a more open society that is now well integrated into the global community. The rapid economic, social, and political transformation of China is surprisingly not a result of predictive planning by any traditional management means but occurred through constant adjustment to the ever-changing social and economic context and by intuitively integrating the old, the new, the East, and the West into many different interpretations. Without successful models or reliable strategies to follow in a social and economic environment that is difficult to predict, Chinese companies are developing their own business models that need to be recognized and understood. Prominent Western economists are sketching strategies to help companies move from the often cost-competitive manufacturing business model to value-added design, branding, or strategic planning, but many Chinese companies, including the better-known giants such as Lenovo, Tencent, and Changhong, are actually practicing all models at the same time. They do this in order to take advantage of low-cost production, developing competencies in design, and growing their brand recognition among the rising number of sophisticated Chinese consumers.

As consumers in China become more financially capable and mature in making their own purchasing decisions, it is not surprising that craftsmanship, delivery of services, and good design become essential attributes of products and services to differentiate themselves from the competition. It is also not surprising that China has learned quickly from the West that innovation, whether it is technologic breakthroughs or stylish new images, is an important strategy that enables differentiation. While companies and talented individuals are searching for ways to capitalize on their creativity,

the Chinese government is learning, developing, and adjusting its policies to support and utilize the imaginative output of the rising creative class of China. Protecting intellectual property, providing policy and financial support, and developing venture capital services are all critical actions that will enable and nurture new generations of Chinese entrepreneurs.

It is true that innovation is not yet well protected in China. Not until 1984 had the Chinese government fully understood and officially recognized intellectual property and is now accepting the largest number of patent applications annually. This is a very respectable achievement. Rapidly growing design education programs and the numerous recently granted of industrial design or creative science parks are signs of the value of government support. And finally, the developing venture capital services will enhance the support necessary to nurture sparkling new business and product opportunities.

While China as a whole is going through a rapid and relatively smooth social and economic transition on a monumental scale, individuals are struggling to comprehend the changes. They may be bewildered by the many conflicting stories coming from many different sources. While many native Chinese believe their nation provides great opportunities, others worry deeply that the controlled political environment would create worrisome uncertainties for the global community. Considering its geographic and population scale, the speed of change, the diversity of social and economic groups, and the dynamism between old and new, West and East, you may agree that there is no single truth, but there are perspectives that are relevant and unique to different individuals and social groups in China.

All economic and political systems, favorable or not, are created by people, and knowing and understanding the people who create these systems is critical for making sense of the circumstances and may in turn lead to a desirable direction. After seven years of living in Hong Kong, serving as Director and later Dean of the School of Design at Hong Kong Polytechnic University, Professor Lorraine Justice has gradually constructed her own unique perspective on creativity, design, and innovation in today's China with a focus on the third generation, the generation that is now in their thirties and forties. This generation is experiencing the monumental transition of China from the older, strongly controlled social and planned economic environment to a much more open society and marketing economy. As Justice pointed out, this third generation is building Chinese capitalism

with little training in business or economics and without much knowl-
edge of the outside world, capitalism is not only a way of how economic
activities are organized but also an ideology that awakens individualism
in young generations of Chinese and shapes their value systems and life-
styles, which are often expressed through identity driven consumption.
Knowing and understanding this generation of Chinese is important
to help envision the future of the country and its impact on the global
community.

People may wonder how Justice as an American is able to provide a
valuable perspective on very complex China. Similarly, I am often viewed
by many Chinese as an outsider without real knowledge of contemporary
China after I have lived outside the Chinese mainland for over fifteen
years. In fact, what surprises these Chinese is when I begin to offer a differ-
ent, yet informed and convincing view of China that they never thought
of. The reason is simple; you can't understand China without knowing
the global context of which China is an inseparable part. This is also true
of Justice's own experience as she mentioned at the very beginning of the
book, "when I went to work in Hong Kong I thought I would be learning
about the East. What I did not expect was that I would learn about the West
as well."

Working in Hong Kong, being friends with many Chinese, learning Chi-
nese culture and language, helping Chinese designers and educators search
for new paths toward their strategic success, Justice is providing an insight-
ful, unique perspective that is shared by and will inspire many Chinese.
The many people that she has met, interviewed, and observed in this book
are presented with empathy and understanding, which has led to the emer-
gence of *China's Design Revolution*, and the focus on the third generation,
a theme that has not been previously explored. Scale, speed, diversity, and
dynamism make it difficult to construct an accurate or focused image of
China, even if it is only on the areas of design and innovation; and there
are possibly hundreds of different views of Chinese design. However, this
book's view is a unique, firsthand, and balanced Western and Eastern views
of China that is worth sharing and reflecting upon.

It is true that as China progresses, it learns and also makes mistakes.
Given its power and scale, there is no reason to expect China to align it-
self with preset international conventions. Design as a discipline may
play a role in helping China develop its own competencies with socially

responsible attitudes, and also has the potential to turn more of the worrisome uncertainties the world may have into collaborative opportunities that will benefit all of us in the global design community.

Xin Xiangyang
Professor and Dean, School of Design, Jiangnan University, Wu Xi, China

Preface

When I went to work in Hong Kong in 2004 I thought I would be learning about the East.

What I did not expect was that I would learn about the West as well. As the differences between East and West began to reveal themselves to me, I realized how individual and youth driven the United States is with the products to back up the dream: art that celebrates uniqueness, motorcycles that represent freedom, blue jeans that represent the pioneering spirit, and entire industries dedicated to staying young. The focus on fashion, sports, and a film industry that likes car chases and explosions fits the formula for staying young and exciting.

In China, the savvy marketing skills of the West came into sharp contrast against a country that was just beginning its capitalistic journey. Today's Chinese consumers are only one generation away from people who had no money beyond what they needed for subsistence. This, in conjunction with the fact that there were very few products for sale and most were government made and issued, did not encourage buying.

After moving to Hong Kong, I experienced a kind of euphoria. I was free of some old problems and habits, and I was blissfully free of U.S. media messages. In Hong Kong, although most people I interacted with spoke English, the everyday language there is Cantonese. I did not understand Cantonese, and so I did not have to take in loud conversations on the train, what hawkers were selling on the streets, or "tiger" mothers scolding their children. Like the family pet, I could understand only when Hong Kong people were happy or sad, when they were about to have a meal, or when they were getting up to leave the room. This lack of verbal stimulus in fact opened my eyes to visual stimuli. Hong Kong is a very beautiful city.

In the United States, in a very individualistic way, we are quick to point out who we are and what we do. This information explains our status in society and our role in business; it plants our feet on the ground and claims our personal space. We present a version of the world in relation to who we are and where we fit in, with the focus on "I." Our business cards hold the minimum criteria for clues to our worthiness and importance.

In Hong Kong, a business card contains a lot of information: academic and business credentials, business group memberships and offices held, and society memberships, for example. All of this information puts the person in a larger and more complex context than what we receive in the United States where our business cards seem to signal, "Just give me the big news right away, and let's see how we connect." Our business cards are baffling to some people in Asia with their lack of clues as to our importance and the minutiae that help to place each of us in societal and business contexts.

Confucian humbleness is still alive in Hong Kong. In the United States, in contrast, we must first sell ourselves to others by offering what we have done in the past as an example of how well we can perform. People in Hong Kong do not talk about themselves and their personal achievements, only what was accomplished by a business group or family, which sometimes is one and the same.

What I came to really value about the West is independence in making decisions and taking responsibility. There is an ethical quality and fearlessness in the United States that allows work to move quickly with a laser focus, perhaps signaled by the term *action item* that typically is part of all agendas for U.S. meetings. Asians tend to work in groups, follow many rules, and worry about saving face, which can hinder processes. Mistakes are not welcome.

The United States can learn from the East to slow down a bit and mull over all consequences in complex scenarios. Consider the term *design thinking*. Its value in my estimation is that it comes close to a mix of East–West thinking. Design thinking requires problem solvers to assess issues on several levels and in various areas and contexts in order to truly understand the problem. But many Western companies do not want to take time for a careful analysis of the problem at hand or evaluation of a finished product. But the rest of the process of design thinking and creative problem solving does represent the Western penchant for action and fast results.

I believe that anyone who claims to know China who was not born there cannot claim to know the complexity and depth of the country, the culture, and its people. Even Chinese who have lived in only one province do not have a complete understanding of their country as a whole. Their history, cultures, and beliefs—Buddhist, Confucian, and Taoist—have shaped the people of China for over five thousand years.

As a Westerner, I humbly attempt in this book to explain the former locus of creativity in the Chinese culture, which I believe is very different from Western creative culture. I describe the impact of Chinese history on creativity and innovation and recount the abrupt change in creativity and innovation at the start of the People's Republic of China (PRC) until today. I hope *China's Design Revolution* brings to Western readers a deeper knowledge of China and its people. I also hope that Chinese readers will feel pride at what has been accomplished through the hardships of the past. My ultimate hope is that the cultures of East and West can borrow from each other to formulate the best design thinking processes for the world.

Lorraine B. Justice

Acknowledgments

I owe thanks to many people who have helped me with this book. First, I thank posthumously my agent, Carol Roth, who sadly passed away as I was writing this book. She was a mentor to many, and her passing is a loss to the publishing field.

I am most grateful to Doug Sery, senior acquisitions editor for New Media, Games and Design at the MIT Press, who first recognized the contribution this book would make to the field of design and China studies. Doug is a respected talent in the design and publishing worlds. Katie Helke, assistant acquisitions editor, has been a caring and knowledgeable support at the MIT Press, and I greatly value her assistance. Ken Friedman, Erik Stolterman, Joseph Koncelik, Craig Vogel, Bill Moggridge, Bruce Claxton, Kimberly Elam, Kai-yin Lo, and Gino Yu all helped me on the early path to creating this book.

I also thank the man who helped bring me to Hong Kong, Victor Lo. Victor has worked tirelessly to bring international designers and events to Hong Kong through the annual Business of Design Week and other educational programs with the Hong Kong Design Center. He created an impressive era of design in Hong Kong through partnerships with countries such as France, Germany, Italy, and Sweden. He is a true and generous friend of designers, and it is my honor to know and work with him.

In my eyes, my personal assistant Kelly Chan, Asia's most thoughtful, intelligent, and efficient woman, cleared a path for me to complete this book. Xin Xiangyang, whose life story is as interesting as his work, was instrumental in connecting me with important designers I needed to meet in Beijing and Shanghai. Henry Steiner, a brilliant man and gifted designer, helped me sort through ideas related to Eastern–Western art and design through many lunches in Hong Kong. Other thanks go to Ming Xi Tang,

Fanny Leung, Rennie Kan, and Pierre Tam. The folks at the Hong Kong Design Center such as Freeman Lau, William To, Amy Chow, and Stanley Chan, are talented friends and a great help for design in Hong Kong. The Hong Kong Trade Development Council is a strong support for design in the region. The Hong Kong Museum of Art was especially helpful, and in particular Woo Cyn-man.

I also thank Jim Hackett, Mark Baker, Joyce Bromberg, Melanie Redman, and Sudhakar Lahade of Steelcase for sharing their research findings on China with me. Steelcase is a a special company that works to understand people and their work spaces.

Special thanks go to my mother, Mary Baiardo, and my sisters, Elaine Gizler and Mary Ann Kocher, whom I have often missed because I live in the East. I am also indebted to support from Nick Yang, Timothy Tong, Philip Chan, Tim Fletcher, Jessica Bellas, Harjeet Vridee, and Timmy Justice. I recognize Gladys Dout, who introduced me to Chinese culture when I was twelve years old, and for her open-mindedness at a time when the world was not very open. My indebtedness and gratitude know no bounds when it comes to my husband, Steve, and our daughter, Alexa. They believed in me enough to leave our comfortable American dream to explore the other side of the world.

1 Introduction

The opening event in the Bird's Nest Stadium for the 2008 Summer Olympics in Beijing stunned the world with its scale, precision, sound, and beauty. The intricate costumes, drumming patterns, displays of technology, and sheer mass of performers showed China at its finest hour. More than 2,000 musicians pounded drums simultaneously. The number of performers at the opening event, 14,000, was greater than the number of athletes in all the subsequent sports competitions put together: 11,000.[1] The originality and huge scale of the opening performance were undeniably powerful. For viewers in the West, the ceremony inspired both excitement and fear, leaving them to wonder what was taking place in this new China. Should they worry about this formidable combination of talent and discipline?

The 2008 Olympics ceremony was representative of China's plans to achieve global respect, drawing on its strengths of harmony, organization, and the deep roots of its history and culture. China's government is now looking to a future where creativity, design, and innovation play an important role in empowering its people and helping it become a sustained economic superpower. New design education programs, privatized companies, innovation parks, and returning scholars will help solidify China's position as a creative power as well, echoing the success of the United States in programs on science and innovation in the 1950s and 1960s. It is through China's workers now in their thirties and forties, the third working generation of the People's Republic of China (PRC), that this new cultural evolution will be achieved.

The Third Generation

Twenty years is the usual number to define a generation and its culture.[2] The Chinese workers who helped Mao build the PRC and endured years of

upheaval, now in their seventies and eighties, comprise the first genera-
tion. Their sons and daughters, the second generation, now in their fifties
and sixties, experienced years of hardship during the Cultural Revolution
and had little chance of getting a higher education.

Those in the third generation, in their thirties and forties, have had
more freedoms than any previous generation since the start of the PRC in
1949. They have chosen their own course of study, their spouse, their job,
where they live, and what they wear. They also have a freedom of speech
today that was unheard of in past decades, though still with some con-
straints. And they are now working to build the new capitalism in China.

It is this third generation of China that is so important to the world as
they provide the link between the old and new China and will determine
in the next few years how quickly China will move ahead economically.
Most of them, the only child in their family, are a curious mix of old values
and new ones, communism and capitalism, Confucian and Maoist phi-
losophies, young in some ways and yet mature in others. The burgeoning
economy of China, along with its centuryies-old value for education, serves
as a backdrop for this generation to live a new way of life.

This generation feels pressures that the other two have not. Responsibil-
ity as only children for caring for their aging parents, skyrocketing housing
costs, a quickly changing competitive business landscape, and a burning
desire for products and luxury have set up a host of complex and conflict-
ing issues for this generation.

History Repeats, Different Country

The surge of activity and Chinese government investment today is similar
to the thrust of science and technology in the 1950s that made the United
States the world's superpower. Unlike the United States, however, China is
focusing on design and innovation and supporting culture and creativity
on a massive scale.[3] The national and provincial Chinese governments are
supporting design and creative activities in first-, second-, and third-tier
cities in order to stimulate economic growth.

The setbacks of the Cultural Revolution during the late 1960s and early
1970s, the closure of universities and schools for ten years, and govern-
ment control over a number of individual choices had a profound effect
on today's older workers. The rapid changes that the second generation is

dealing with have left some with a sense of unease and a lack of confidence in their future. Many of the second generation, now retired, are contending with issues related to rising housing costs, medical care, and the changing makeup of the Chinese family.

Over the past sixty years, Chinese had little experience being consumers. And whereas the United States and Europe took hundreds of years to develop capitalism, consumerism, and the accompanying Western expertise in branding, design, and marketing, China is compressing that time frame to achieve its goal of creating an economy that combines communist and capitalist elements.[4] As a result of this aggressive push, the learning curves for branding, design, marketing, innovation, and intellectual property are sharp. China is in a somewhat chaotic state until a more stable business environment evolves, along with a more even environment for design talent.

Many Chinese universities have started design programs in response to the government's need to cultivate design and innovation skills, but it will take some years before polished, practiced designers start to show up in companies en masse. The creativity, design, and innovation parks being established throughout China are providing an avenue for small companies to learn. These innovation parks are there to help fledgling companies become successful. Individual designers and design companies are learning from each other how to pitch projects, charge for design time, and understand the concept and implications of intellectual property.

In the early years of the PRC, when private businesses and land were confiscated and returned to the government, there was no individual intellectual property (IP). Rather, it was a form of collective IP that belonged to the state. The PRC determined which products would be developed or manufactured, and ownership of ideas was a shared experience.

Art and design schools in China today focus on creative problem solving, but their history of restricted creative freedom and creative opportunity in the early days of the PRC often leads to the marketplace, where copying, rather than original design, is flourishing because of the easy money it brought without the investment of design and development. As more companies in China look for unique ideas, Chinese designers will respond, and the idea of individual intellectual ownership will become more widely accepted. Professional Chinese designers continue to look for clients who will support them in designing something new, working hard to earn their trust, and inspire them to take risks.

Design Thinking in China

When I asked an art dealer in Hong Kong if Chinese people are creative, he paused before asking: "What do you mean by creative? Is it the Western version of creativity where something is created from nothing, as in the Christian belief?"[5] I was surprised by his question and began to consider the implications. It seems there is a difference between creativity and design thinking in China and in the West, and much of it has to do with the individualism expression of the West and the complex contextualization of the East.

In *Geography of Thought*, a book describing how Asians and Westerners think differently, Richard Nisbett's premise is that not only do the Chinese think differently in some areas; they also observe differently.[6] Whereas Westerners are quick to find and focus on a detail, the Chinese relate to objects in context. For example, a Westerner will talk about a deer in the forest, whereas a Chinese person might talk about a forest that has many things, and one of them is a deer. This difference is important for designers. It means that products produced for both Eastern and Western cultures should be analyzed in both cultural contexts. It also means that Western designers working on products to be used in the Chinese market should become knowledgeable about Chinese culture and the ideas of context and harmony. Similarly, Chinese designers producing products for the West need to understand Western culture and the ideas of uniqueness and individual expression.

Design thinking is new to China, and Chinese companies are just beginning to design and produce products for their home market and abroad. Privatization is spurring the need for new products and brand strategies. Where the West is interested in making things unique, individualistic, and attention getting, the East has a long tradition of working within boundaries and guidelines, whether it was for imperialist China or the PRC. This concept is explored in chapter 2, which presents a brief history of Chinese art, design, and innovation.

"Has This Been Done Before?"

A client in the West who asks a designer, "Has this been done before?" usually wants to know if the design is an original. In China, one young

designer at a conference in Singapore was tired of hearing the same question every time he showed his design concepts to a client: "Has this been done before? I want to know if it has sold."[7] What these clients want are copies of products that have been successful on the market instead of orders for fresh and new, but untested, products. Businesses in China often have very small profit margins and are loath to take a risk on something new. This may change when the Chinese people start to buy unique everyday lifestyle products, whether they are Eastern or Western.

When a designer was having a leather handbag made, the senior owner of the shop mentioned that the Louis Vuitton (LV) legal representatives regularly visited shops in the region to inform the owners of possible legal action if they copied LV products.[8] The owner asked the designer whether he thought it would be okay "if he used a different typeface for the L and V" and if he "changed the clasp a bit." The designer spent the next hour explaining why the changes he suggested were too minor to be considered not copying LV products. She told him he could design his own bags and build his own brand because he was very good at knowing what his clients liked. But the shop owner did not believe he could generate business in this way and felt he had no experience designing and marketing his own products.

Confidence Issues

Designers in China express frustration at Chinese clients who do not take their work seriously. Although several successful companies in China understand design and innovation and work well with designers, many small and medium-size enterprises and government-owned companies have no experience in design, innovation, or intellectual property. This is a cycle that China will go through until everyone—clients, designers, students, and educators—is in agreement about the value of design and what it can bring to the economy and culture.

There is a lack of understanding by many manufacturers and brand owners in China of how designers conceptualize new ideas or how these concepts can be changed or redesigned to fit their needs. In addition, hourly pay for design time requiring conceptual concepts or design research is unusual, so Chinese designers bid by the job. Chinese clients are not aware, in many cases, of the concept of design research and the processes of design

analysis and decision making needed to reach a successful design concept. In addition, contracts are not yet well defined and often do not mean much because decision makers in China prefer to work with trusted friends and family.

In the United States, some engineering and sales-driven companies view design as a necessary evil and believe that design research is yet another cost added to an already expensive and unsubstantiated process. U.S. designers tend to stay away from these companies or try to convert them into believers in the power of design. Although the new Chinese companies do not question the need for design, they do not fully understand what the design process can do for them.

Chinese client companies also question the quality of education of design students at Chinese universities because they feel that designers are taught by artists and engineers rather than designers. Chinese design students who study abroad or in Hong Kong have a much better chance of being awarded design work in China, at least until Chinese companies start to respond to local designers.

An added layer of complexity is that China does not yet have the distribution and outlets for mass sales that have been established in the United States and Europe. Walmart, Target, Kohls, JCPenney, Sears, and up-scale stores such as Bergdorf Goodman and Macy's have provided U.S. and foreign companies the opportunity to sell directly to their target audiences and even design especially for particular stores. China is in the early days of setting up chains of stores for varying markets. Some of the major companies, such as Haier, have opened their own distribution and retail channels to exert more control over their displays and sales team.

The Chinese government knows that the higher the value (not necessarily price) of products, the higher a company's net worth may be. When companies produce quality products that they own, rather than just having manufactured them, this experience leads to the next good product. In its reach for major global brands, China has initiated programs to help state-owned and privately owned companies (which are often competing with each other) to secure patents by reimbursing them for patent costs. China was third in the world, behind the United States and Japan, for the number of patents granted as of 2009.[9] Considering the large growth of patent activity in China, it may eventually reach the number one slot in patents granted.

Foreign companies that wish to bring legal action against Chinese companies that copy their products would do well to file for patent protection in China, Hong Kong, and other countries in Asia. As China establishes its own patent system, it will expect companies and individuals in foreign countries to file for patents in China. There may be little assistance enforcing a restriction of copying if patents were not applied for in China.

China's central government and the regional authorities are doing their part to educate people about the concepts surrounding design and innovation. They have set up business development classes in the provinces with curricula that include branding, design, marketing, and other areas of product development. They are also focusing on creating major scientific innovations that will lead to breakthrough products in areas such as textiles, sustainability, and the production of other materials important to product design and manufacturing.

Still, Chinese designers say that their clients do not understand design, view it as too risky, are not confident they will choose the right design for their market, or worry that someone else may have the same idea and act on it before they do. In addition, they do not want to pay for something they cannot see, especially in the early stages of the design process, and do not understand how to build a brand through products and services.

Many U.S. companies know that design is an investment and use it to keep their brand strong. And so many designers, especially Western designers who do work in China, become frustrated by the lack of client sophistication in relation to design. Some Western designers have been able to work successfully with Chinese companies, and their success further undermines local designers' confidence.

The Chinese People Are Creative, but the Systems Are Not

A senior Chinese designer in Beijing, who was employed by the Chinese Communist Party at the height of the propaganda years during the Cultural Revolution, was asked if the Chinese people consider themselves creative. After a long pause he replied, "Yes, Chinese people are creative. But they have thousands of years of Confucian conditioning, which does not promote change outside of its ideals. This was followed by the early years of

the tight government control on anything expressive. The creative urge in Chinese people is still there, although it has been dampened. Educational and corporate systems must change if creativity is to thrive."[10]

The move from being a society in which all companies are state owned to one in which privatization and entrepreneurism are norms, is unsettling for some Chinese workers. Today's older men wore standard Mao suits during the Cultural Revolution and the women wore drab clothes, used no makeup, and had cropped hair. There was no room for personal self-expression. Men and women could purchase only the narrow selection of products that the government made available. This means that the parents of today's third generation had little experience with cars (purchasing and driving them), had only a small selection of electrical appliances and phones from which to choose, and owned few (if any) books, beauty products, school supplies, computers, and other goods that are common today. Homes had little furniture other than the basic pieces such as a table and chairs, a cabinet for clothes, and a bed.

This was the experience of the third generation of workers today in the PRC who are now the pioneers of capitalism in China. Today's younger generations in China—the fourth (those in their teens and twenties) and fifth (children in elementary school)—now have many freedoms their parents did not have, but they often lack confidence and look to the opinions of their peers and the information on the Web when they are making decisions. And this is the reason that brand names and trends are so important in China: brands that other people have chosen seem to be safer purchases, and famous names do sell products in China.

The New Company Creatives

When I interviewed Yao Yingjia, vice president of innovation at Lenovo, a leading international Chinese computer brand, and a lead designer of the 2008 Olympic torch, it was evident that he had given a lot of thought to working creatively within a company framework. Companies, he said, should be structured to "use design as a bridge."[11]

Yao, who often goes by his surname only, believes that Lenovo's success has stemmed from good senior leadership, a competitive environment, a design team that has the confidence to try different approaches, and a multifunctional team whose members come from across various disciplines.

His own team is made up of industrial designers, graphic designers, mechanical and electrical engineers, interface designers, and new materials engineers. "But to really succeed in innovation," he says, holding up both hands as if supporting an imaginary sphere, "you need ten fingers touching innovation." In other words, you need many areas working together to raise the level of innovation.

Defining Creativity, Innovation, and Design

The Chinese people have a long, rich history of development in the arts and innovation. Over centuries they created innovations that let to revolutions in farming, time keeping, warfare, and navigation. Their arts and crafts, largely influenced by Confucian ideals for preserving the past, increased in quality with seemingly incremental changes. But today's design activities are largely Western in nature, individualized for consumer wants, needs, and desires.

Csikszentmihalyi, who wrote the seminal books *Flow* and *Creativity*, defines *creativity* as "a unique shift in a domain," meaning something that has not been done before.[12] A person who is seeking to create something new in a field, whether it is medicine or design, has to understand the domain, or area of study. For it to be a major contribution, the product needs to garner recognition from the field by peers. Would Michelangelo's *David* or Marcel Duchamp's *Nude Descending a Staircase* be considered worthy of high praise in China according to traditional ideals for art and culture? A more important question may be: How is creativity evaluated and valued in other cultures?

Western designers strive to achieve a major creative contribution and innovation in their work. Their education prepares them to design something entirely new or to revise and improve an existing product. A product's form, color, material, shape, texture, and function communicate whether the piece is desirable. For traditional work in China, there must be conformity to certain visual aspects. To the untrained Western eye, it may seem as though there were only incremental changes in Chinese art from century to century because the West is always on a quest for new and unique things that represent individualism.

China is gathering Western knowledge and influence in several large domains such as the arts, sciences, manufacturing, and business methods

and combining these to blend Chinese and Western methods. Currently, creativity and innovation tend to occur only in increments rather than in large, dramatic changes as in the West. Nevertheless, Chinese designers are starting to move toward Western ways of thinking about design. The recognition of the value of those shifts will be judged by a larger global audience.

China, the Country

China was a leading civilization in the world for centuries, although the country faced setbacks from time to time. The reason, according to some scholars, was the importance of Confucian ideals, which seemed to look back rather than forward.[13] In the late nineteenth and early twentieth centuries, more setbacks in innovation occurred due to "civil unrest, major famines, military defeats, and foreign occupation." Recent diseases such as severe acute respiratory syndrome and bird flu limited productivity intermittently in, respectively, 2003 and 2007.

China today is made up of twenty-three provinces and is slightly smaller than the United States. It has a labor force of more than 760.8 million workers, according to the 2005 *World Factbook* on China. China is largely Han Chinese, at 91.9 percent, with the balance a variety of ethnic groups: Zhuang, Uighur, Hui, Yi, Tibetan, Miao, Manchu, Mongol, Buyi, and Korean. Putonghua is spoken in the north of China, and Cantonese largely dominates the Guangdong and parts of Guangxi provinces in the south of China. Dialects vary from province to province.[14]

The connection between the differing groups and provinces is the written Chinese language, shared by all Chinese people. During Mao's chairmanship, mainland China switched to a form of the written character called "simplified Chinese." Hong Kong, Macau, and Taiwan retained the traditional Chinese letterforms, and although they can understand the simplified characters in most cases, younger mainland people may have difficulty reading the traditional Chinese characters.

Over 50 percent of the people in China are farmers, but only about 10 percent of China's land can be used for farming, a cause of hardship for the Chinese people, especially in the wake of natural disasters such as flooding or man-made disasters such as uprisings and war. By the late-1970s and early 1980s, Deng Xiaoping, the reformist Communist Party

Leader, began to "open up" China by allowing foreign companies to part-
ner with companies in China. By 1984 China had collectivized its coopera-
tive farms, increased agricultural production, and instituted the one-child
policy, whereby each couple was allowed just one child. This policy was
reinforced by fines or sterilization of the female if a second child was born
to a couple. Rural families, however, were permitted to have more than
one child per couple.[15] The one-child policy resulted in more wealth and
education available from parents and grandparents who did not have such
opportunities.

Imbalance of Wealth: Only 650 Million Customers in China

Most books written on China are about business and government. The
rest of the world wonders how it can sell to China's huge internal market
of 1.3 billion potential consumers. In fact, those potential customers
are not like Western customers, who have the means and desire to buy
products and services. With over half of China's population residing in
villages and rural areas[16], these potential consumers have neither the
means to buy or the access to purchase many products. Even workers
who have moved from the villages to factories have little extra money
but anything but their basic needs; they send money to their families, or
save for trips home, or purchase an apartment or car. The middle-class
residents of cities spend most of their disposable income on a house or
apartment. Moreover, credit cards and other forms of bank credit are
not as freely available or as common as in the West. Chinese people
buy products from the Web and pay for those products when they are
delivered to their home, or they go to a local shop to pay for and pick up
the goods.

Most of the products newly manufactured in China are for Western mar-
kets, not internal ones, and product design—both appearance and func-
tion—follows that in the West, but this is changing rapidly in response
to the Chinese government's call for a focus on domestic markets. When
designers in China start creating and innovating for their own markets, we
will see China make a major cultural contribution to the world in the area
of product design. The products will start to reflect the culture of China
through their color, shape, form, texture, and content, and then we may
see a major shift in the product design domain.

First Get Rich

During the early 1980s, artists in the north of China were putting together shows that were radical for the time and pushed the limits of conservative China. Groups and collectives of artists with names like New Figurative and New Analysts Group were established by some of the first artists to emerge from the newly opened universities after the Cultural Revolution era.[17] These artists rebelled against their culture, just as the former generation had rebelled against the older and traditional culture of China. In the south of China, in Shenzhen and Guangzhou, graphic designers pioneered their own independent design practices, taking on second jobs to do the design work they loved.

In 2006, the Victoria and Albert Museum of London held an insightful and well-researched exhibit, China Design Now, and published a comprehensive book to complement the works on display. This book notes that the members of the generation of the 1980s were only children who, "growing up in the 'Reform and Opening Up' period, . . . are under the influence of China's rapid economic growth, urbanization and commercial culture. People of the Eighties generation in big cities are characterized by the public and press as fashionable, self-centered, fame-seeking and creative; always ready to challenge traditional values."[18]

This third generation is spurred on by the mantra of, "First get rich." For this urban middle class, the authors say, "The home has become [their] status symbol." They identified "four great things" that well-to-do Chinese families aspired to before the 1980s as "a radio, a watch, a sewing machine, and a bicycle. Later the list changed to a refrigerator, a television, a tape recorder, and an electric fan. By 2000, people could expect to acquire a different set of products: a car, a mobile phone, a laptop and an apartment."[19]

Moving Forward While Understanding the Past

The current Chinese government has been bold and masterful in its plan to bring more personal freedom to the people when there is no way to predict how the people of China will react. China is a country with a tumultuous history, largely stemming from rural unrest and discrepancies in prosperity between the cities and farms.

This book provides insights into the third generation in China through examples of design, innovation, and creativity; interviews; examples of digital media, graphic, fashion, interior, and product design. It shows examples of the work of these design change agents, along with interviews on topics of creativity, personal expression, and freedom of lifestyle and what these mean for China today.

The changes that are now taking place in China, largely led by this third generation, are tremendous. Starting with the opening up of China, the courage of Chinese people to create art, design, fashion, film, and literature is evident in their quest for self-expression. But the environment for creativity and innovation is vastly different from that of the past and has put China on an entirely new path. The practice of imitating a master is largely a thing of the past as this generation strives for self-expression, fame, fortune, and the need to engage with the rest of the world. Many of today's designers in mainland China now follow a Western process of external motivation and inspiration for their work.

China's Design Revolution is a book for those interested in Chinese creativity, design thinking, innovation and marketing in China, and Chinese history. The government focus on design, creativity, and innovation infrasructures in China today mirrors the passions of the people for creating new spaces, places, products, and entertainment. *China's Design Revolution* illuminates this significant and important turning point in history that is taking place and will surely change China and the rest of the world.

The products that people make and use reflect their culture, and products being designed and made in China now are clues to the changes that have taken place in recent years. Chapter 2 explores traditional culture, creativity, and innovation in China in order to give readers a basic understanding of the radical shift in lifestyle and artifacts after the Chinese dynasties came to an end. Chapter 3 also briefly recounts the state-run lifestyles of the first and second generations and the design in Chairman Mao's era. Chapter 4 recounts the third generation, who are helping to create the new economy of China.

Later chapters explore award-winning digital, fashion, graphic, and interior and product designs, followed by current lifestyle, purchasing trends, and the fourth generation (those in their teens and twenties). It ends by

looking at the way forward for those who want to explore creativity and innovation in China or become a part of it. As you read this book, you will see the need for its holistic approach because separating Chinese design and designers from their culture, history, government, and current events is difficult, and maybe impossible.

2 From Master to Mister: Influences on Chinese Design from the Past and Present

Chinese periods of history are classified according to dynasties (table 2.1). Each dynasty may have had many rulers or emperors over its course, depending on how long the people believed the emperor had the mandate of heaven to rule.[1] Each dynasty varied greatly in strength and influence, length and wealth, as figure 2.1 illustrates.

During each dynasty, art and artifact design were influenced by cultural norms and their rulers. The most noticeable changes in visual styles were seen in the art, dress, and daily life objects between the Han, Mongolian, and Manchurian rulers. The Han people, who make up most of China today, are indigenous to the Chinese region.[2] The Mongols came from the north and the Manchurian rulers from the northeast, close to present-day Korea.

Other influences on Chinese art and artifact design came from the Confucian, Daoist, and Buddhism schools of thought.[3] The most profound and longest influence came from Confucius (551–497 B.C.), who lived during the Eastern Zhou dynasty (770–256 B.C.).[4] Confucius, like the Greek sophists of the same time period, was concerned with the morality of his day. He preached harmony and moderation, values that are still held in high esteem in China.

Calligraphy was one of the skills to be mastered by intellectuals and leaders of China as a visible indication of their moral character. Chinese calligraphy has maintained a consistent and special place in the lives of Chinese people, unifying them through the ages.[5] Chinese people residing throughout Asia today are able to read Chinese text, even if their Mandarin, Cantonese, and local dialects do not allow spoken communication.

Figures 2.2 and 2.3 reflect the evolution of calligraphic styles in China. The earliest script was found on bones dating back to 1300 B.C. They were

Table 2.1
Chinese Dynasties

Paleolithic	c.600,000–7000 B.C.
Neolithic	c.7000–1600 B.C.
Shang	c. 1600–1027 B.C.
Western Zhou	1027–771 B.C.
Eastern Zhou	770–256 B.C.
Spring and Autumn Annals	722–481 B.C.
Warring States	480–221 B.C.
Qin	221–206 B.C.
Former (Eastern) Han	206 B.C.–25 A.D.
Later (Western) Han	25–220
Three Kingdoms	220–265
Western Jin	265–316
Northern and Southern Dynasties	317–589
Northern Wei (Toba)	386–535
Sui	589–618
Tang	618–907
Five Dynasties and Ten Kingdoms	907–960
Northern Song	960–1127
Liao (Khitan)	907—1125
Southern Song	1127–1279
Jin (Jurchen)	1115–1234
Yuan (Mongol)	1279–1368
Ming	1368–1644
Qing (Manchu)	1644–1949

Source: All China, 17.

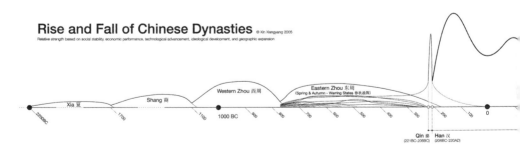

Figure 2.1
Diagram of the Chinese Dynasties According to Strengths, by Xin Xiangyang.

called oracle bones due to the belief that the "magic symbols" inscribed on them could bring health when ground and used in medicine. The inscribed bones were also used by priests for contacting the spirit world. The calligraphy in the style of Cao is a systematic and uniform calligraphy.

Calligraphy has been considered an art for centuries in China. Special calligraphic poems and couplets adorn Chinese paintings or flank the doorways of homes. A Chinese painter who was adept at calligraphy could blend it easily with the same style used in the painting of a figure or landscape for a more uniform visual communication, increasing the quality of the work and his or her own esteem.

Chinese art and artifact design influenced by Confucian values helped to preserve the traditions of harmony and connecting humans to nature.[6] Traditional art in China was based on expressions of serenity, tranquility, and nature shown through quiet landscapes with animals or with women and men taking part in leisurely activities. Unlike Western art, which often depicts violence, death, and other shocking imagery, these images were largely nonexistent in China.[7] Other than an occasional battle scene, depictions of fierce dragons in Chinese art and dress were the images most closely related to aggressive emotions. By the 1700s, European audiences were used to dragons and gargoyles in their own cultures, but they preferred the Chinese flowers and landscapes to grace their pottery.[8]

Buddhism spread throughout China during the Northern Wei dynasty (386–535). Earlier, contact with other countries, including India, had an impact on the Chinese empire adopting Buddism.[9] Buddhist imagery in China lost much of its Indian visual influence, and by the Tang dynasty

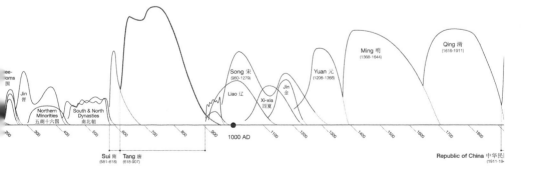

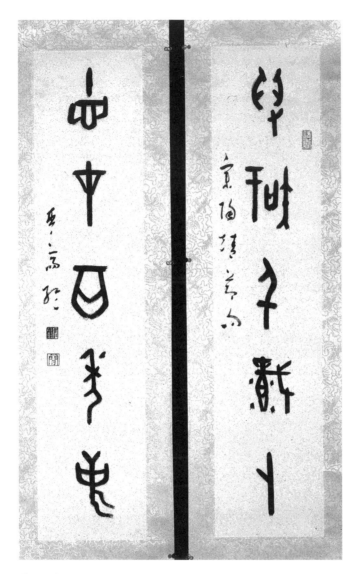

Figure 2.2
Couplet in oracle bone script, which uses pictograms as the basis of communication.
(Hong Kong Museum of Art Collection.)

(618–907), Buddhist symbols had become Chinese in visual appearance. Mandalas, pomegranates, open hands, peacocks, an eye in the palm of a hand, and the famous reversed swastika used in Buddhist works of art can be found in temples and homes and on everyday objects in China. The lotus blossom, said to represent spiritual wisdom unfolding, is seen throughout China. Bells were used as the voice of heaven to remove evil spirits.

Daoism, attributed to Lao Tzu, is believed to have flourished at about the same time as Confucius.[10] The philosophy behind Daoism, called "the Way," urges people to move through life with ease and flow rather than self-effort, to stay in a natural state, and to refrain from interfering with one's life path. The best-known symbol, the yin-yang circle, is a visual metaphor for male-female, light-dark, high-low, and other dualisms.[11]

In China's long history, visible influences on art and objects had a continuity that ended with the revolutions of the 1900s. With the country in chaos from invasion and civil war, traditional fine art in China was also under attack. Mao's Cultural Revolution brought a serious break with the past, including traditional art and what it represented.

Creativity in China

Western culture rewards individuality and self-expression, and Western artists often seek bold and dramatic change. Traditional Chinese creativity in art, however, did not seek bold and dramatic change. Instead, Chinese artists copied a master or a work of art within a genre until the artist understood the path of the master.[12] Painting in traditional Chinese art is in categories such as landscapes, figures, and flowers and birds.[13] When artists in the West create for clients, they use a strong individualistic style. Western artists such as Michelangelo and Leonardo da Vinci, for example, used their skills to express visually what they believed was the central message of their art, whereas Chinese traditional artists created within the genres of Chinese art and did not always expect an audience for their work, as it was more of a private and internal process when planning and making the artwork.

Art and creativity in China may seem not to have changed over the centuries, and in fact, advancement, or significant visual change, is not a criterion for assessing Chinese art as it has been in the West. Therefore, what is appropriate for Western creative activities may not be appropriate for

traditional Chinese works of art or artifacts. Chinese traditionalists would judge a work of art, and its inherent creativity, according to how well it adhered to the norms of the genre in which it was created and the artist's skill and talent. The art would sometimes hold a small surprise or ironic interpretation. As we will see later in this chapter, the "sketching thoughts style" requires a minimum of brushwork to depict a subject and convey the character of the subject. Westerners who do not understand this style might think that a piece appears to be unfinished or childlike in its appearance, much like a Chinese person might wonder why a piece by Mondrian, with its simple colors and lines, is popular in the West.

Early Products

Product inventions in China seemed to slow as the strength of the dynasties began to take hold. This is sometimes attributed to the abundance of personnel and the weight of bureaucracy in the ancient Chinese imperial courts. Incentives for creating new things were small, and any exceptional item that was created was immediately taken in by the court. The Confucian philosophy of preserving the past also found its way into the consciousness of the people and may have affected the desire of Chinese people to do new and innovative things.

These early inventions in China were significant. Paper and movable type, often believed to be inventions from, respectively, Egypt and Europe, were actually created in China in the second century B.C. Paper, which differs greatly from papyrus sheets, is made of fibrous materials soaked and settled into a flat pulp that is dried. The earliest paper made in China was dried on woven mats and used for clothing, wrapping, and personal hygiene.[14] A record of a government official telling a young prince to cover his nose with paper may indicate that the first tissue was invented in China. Because the quality of paper was coarse, it was not used for writing until 110 A.D. The first movable type in China was made of hardened clay in 990 A.D., long before Gutenberg developed movable type in 1440.[15] The clay type was set in a frame like the Gutenberg type and used for printing copies.

In the fourth century, those who enjoyed an elegant lifestyle had access to a few inventions. The first umbrellas were made of bamboo and silk.

Later umbrellas were made of bamboo and oiled paper. The first plastic may have been lacquerware, made from the resin of the lac tree, which was used to coat furniture and objects of daily living. Beautifully carved lacquerware tables, chairs, and screens exist today as evidence of this early aesthetic material.

The famous blue and white pottery of the Ming dynasty (1368–1644) had its start in the Tang dynasty (618–907).[16] The blue and white pottery became so admired that, it is estimated, as many as 60 million pieces were shipped to Europe and the United States before 1800. Trade, but not desire, for the blue and white ware dropped when Great Britain, the Netherlands, and the United States realized they could make reproductions that were more affordable than those from China. Delft was the first city in the Netherlands to set up shop to produce this "china"; plain white porcelain was shipped from China and decorated in the Netherlands with Dutch motifs in a blue glaze.

Early Chinese inventions related to agriculture, such as the bronze plow and seed drill, led to a strong agricultural society. The improved horse harness enabled goods to be carried long distances without damaging the horse. The crossbow and fireworks, precursors to gunpowder, were also invented in China. Kites, invented around the fourth century B.C., were used in military warfare by 550 A.D. as a form of communication.[17]

Early scientific inventions such as the compass and the seismograph were examples of design that was both functional and beautiful. Still in existence is an early compass used to navigate the China seas, engraved and colored, with its needle fashioned in the form of a fish. Another example of a beautiful and playful scientific piece is an ornate bronze seismograph consisting of a container with holes equally distributed around the lip. Seated outside the container are bronze toads with their mouths open, also equally distributed. When an earthquake struck, a bronze ball would roll from the container and drop into the mouth of a toad. The toad that received the ball indicated the direction and epicenter of the earthquake.[18]

Visual Symbols

The calligraphic symbol representing China, a rectangle with a vertical line slashed through the center seems to visually indicate how the Chinese

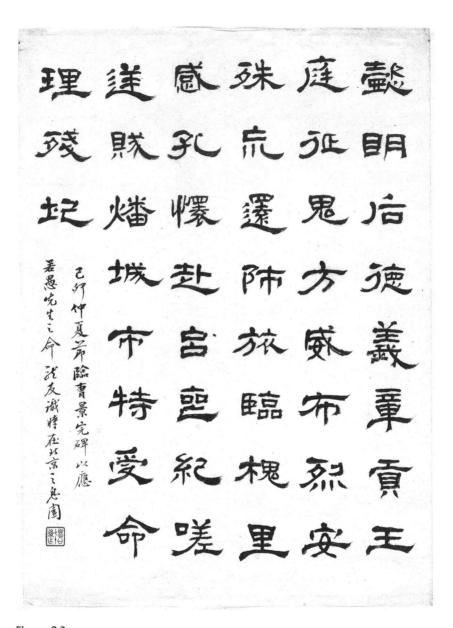

Figure 2.3
Clerical script after the style of Cao. This practiced and controlled script indicates hours of work to achieve a uniform style of writing. (Hong Kong Museum of Art Collection.)

thought about their country, which they called the Middle Kingdom, or center of the world. This view of their world held until visitors such as Marco Polo and Jesuit priests, bringing products and information from the West, visited in the 1200s.[19]

Animals; colors; flowers; fruit; nature's elements of air, fire, metal, and wood; and numbers have symbolic meaning in China. In the East, wealth was considered a blessing, and so images of fish, which spawn easily, and the rat, which finds its way to riches, are often found on Chinese holiday greetings. The Chinese zodiac uses animals to depict character and ways of being. Flowers such as the plum blossom show strength by surviving through the winter. Hardy chrysanthemum can withstand early autumn frosts. The lotus blossom represents fertility, and images of boys holding a lotus blossom can be found on decorative pieces and wall hangings. Grapes symbolize fertility, and orange fruit is associated with prosperity because of its color. Bamboo, which is simple and upright, reflects the preferred humble and moral status of the Chinese people. Traditional Chinese homes before the start of the revolutions in the 1900s often had symbols carved into the woodwork or painted on screens, serving as a reminder to attract wealth and grow a large family.

Dragons are considered signs of power and nobility. The dragon processions in China today denote blessings and protection. Two lions, one male and one female, are often seen flanking doorways of temples, palaces, or homes. The female lion is identified by its foot resting on a pup, and the male has its foot on a ball that represents the earth. Stylized clouds are found throughout China in paintings, sculptures, pottery, and furniture, carved into wooden parts of the home, palaces, and temples. These stylized clouds, which represent heaven and aspiration, graced the 2008 Olympic torch designed in China (figure 2.4).

Chinese Art and Artifacts

The earliest art in China existed as drawings on rocks and murals on cave walls. Chinese calligraphic symbols started as drawings depicting people, animals, and other elements related to daily life. Early clay pottery was decorated with simple shapes and figures. Figure 2.5 shows the early blue and white pottery that was the precursor to the famous blue and white

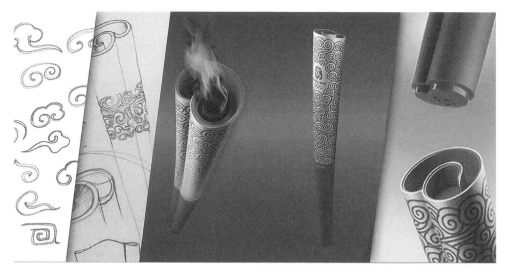

Figure 2.4
The 2008 Olympic Torch ideation sketches from Lenovo.

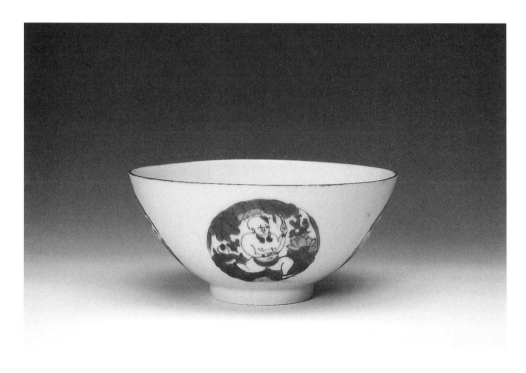

Figure 2.5
Early seventeenth-century bowl with a design of babies and lotuses and a blue under-glaze. (Hong Kong Museum of Art Collection.)

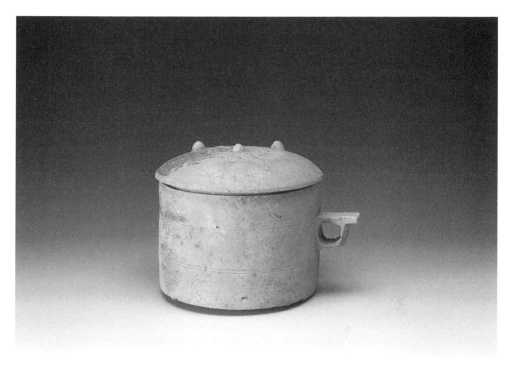

Figure 2.6
Eastern Han (206 B.C.–25 A.D.) gray pottery covered cup with handle. (Hong Kong Museum of Art Collection.)

porcelain of the Ming dynasty. Figure 2.6 shows one of the earliest covered cups in China, a precursor to the ones we see today sitting on conference tables throughout China (figure 2.7).

Bronze statues, which appeared as early during the Eastern Zhou dynasty (770–256 B.C.), were intricate due to the allowances provided by the lost wax method of casting. The lost wax method allowed small details to be sculpted into the wax and was used to create ornate figures, jewelry, and vessels.

Early cooking stoves were fuel efficient. Their small orifices channeled heat to the base of the cookware while protecting the fire from the elements (figure 2.8).

The playful expressiveness of early artifact designers is shown in the vessel in figure 2.9. The forward motion of the piece and the stance of the legs give the impression of a small dog willing to please its master.

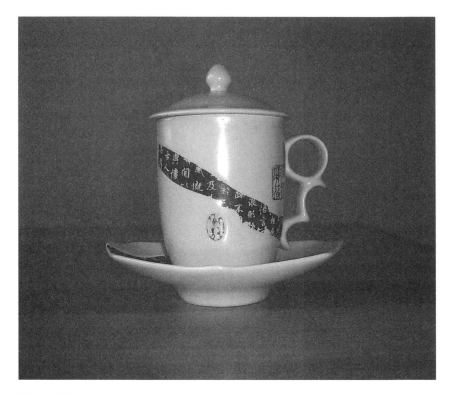

Figure 2.7
Modern Chinese tea cup. (Photo credit: Xin Xiangyang.)

Chinese paintings were created to reveal the artistic impression of the object. The artist would feel the temperament of the person, mountain, animal, or plant he was painting. According to the author Jin Yong of *Arts in China*, a painting should "reflect the interior world of the painter. That is what a Chinese painting requires; imitation of nature guided by the soul."[20] Artists who were held in high esteem were adept at painting, calligraphy, poetry, and seal cutting or chop making, all three of them represented in traditional Chinese paintings.

Three types of art emerged throughout the Chinese dynasties: figure, landscape, and flower and bird. Figure paintings aimed to reveal the inner qualities of the person depicted (figure 2.10). The woman depicted in figure 2.10 represents femininity, peace, quiet, and solitude. Landscapes allowed viewers to take an "inner tour" of nature when reflecting on a scene. They were created to reveal the philosophical belief that people can

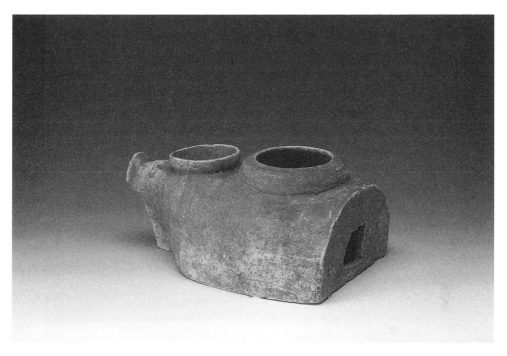

Figure 2.8
Western Han (206 B.C.–A.D.220) gray pottery stove with small orifices. (Hong Kong Museum of Art Collection.)

find happiness in nature (figure 2.11), and flower and bird paintings (figure 2.12), also used to remind people of harmony with nature, were produced to be representative and true to nature.

An important painting style that arose during the Southern Song Dynasty (1127–1279)e was the *xieyi*, or "sketching thoughts" painting (figure 2.13). The style displayed a seemingly informal type of art that had various categories, referred to as high sketching thoughts, regular sketching thoughts, and semisketching thoughts, all referring to the character of the freehand strokes and level of visual detail in the painting. Sketching styles were designed to capture the spirit of the subject and were not intended to be objective portraits or expected to be wholly representational. Although the sketching styles had minimal detail and and a simplistic look, great skill was necessary to find the combination of quality of line and limited detail to depict what the artist had in mind to communicate.

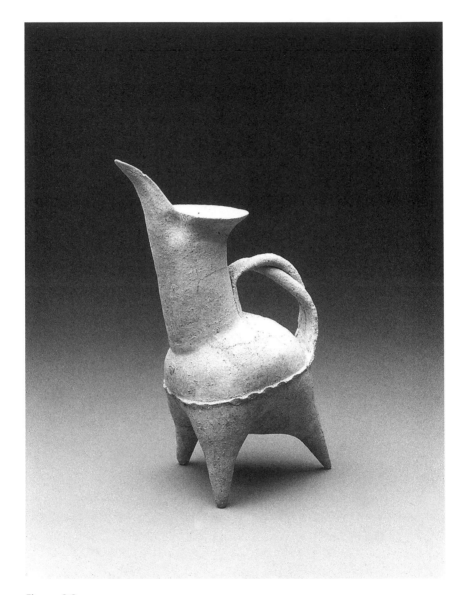

Figure 2.9
Neolithic period (c. 7000–1600 B.C.) pottery *Gui*, or wine vessel, with twisted handle.
(Hong Kong Museum of Art Collection.)

Figure 2.10
Woman carrying a *qin*, or vaselike object that represented China using round and square imagery (1943). (Xubaizhai Collection, Hong Kong Museum of Art.)

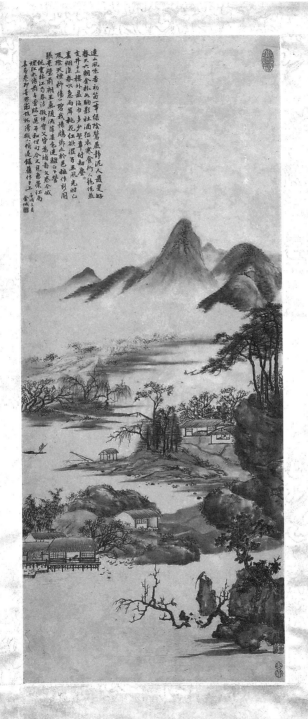

The "meticulous style" consisted of line drawings that were consistent in weight and often outlined and defined the subject's contours. Color was applied in light tones or rich patterns. Paintings in this style had a uniform texture and contrast.

The small red stamps on all paintings were from carved seals, or chops. They first appeared on early monochrome ink paintings and calligraphic work and were used as the artist's signature. Additional red stamps that are often on the painting signified the owner, or owners, who collected the work.

Products and fashions created during particular eras drew on the different painting styles. Vases and other ceramics pieces carried a variety of painting styles, as did furniture and interior wood pieces such as screens and doors. Poems and couplets done in expert calligraphy adorned the walls and doors of the homes. Gardens began to reflect landscapes of nature, and, in extreme miniature, the bonsai was born.

The Chinese Home

Feng shui (wind, water) and the forces associated with it are taken as seriously today by many Chinese, and people in the West as well, as they were in the ancient past. As early as the Western Zhou period (1027–771 B.C.), feng shui was used to identify suitable sites for building dwelling places. The outlying terrain was considered when planning a home, and guidelines such as having mountains to the back of the home and water to the front were signs of favorable feng shui. It integrated the home into the elements of earth, wood, water, metal, and wind and connected it with nature.

In the West, people have aspired to have a house that is unique in its design, whereas the Chinese preferred their homes to be similar to other homes both inside and out, from the layout of the rooms to the materials used. Cultural norms and philosophies and methods such as feng shui help create those similarities.

Regional variations due to terrain and climate were addressed through sensitivity to nature. Early houses were naturally ecological structures that

◀ **Figure 2.11**
Spring landscape after Huichong (1922). (Xubaizhai Collection, Hong Kong Museum of Art.)

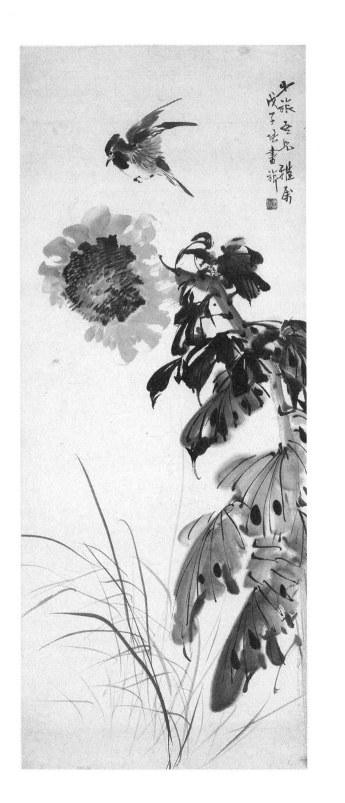

made use of local materials and the setting of the house in relation to the land to assist with heating and cooling. A courtyard was important, for example, because it helped to cool or heat the house and provide ventilation. In *China Style*, Sunamita Lim describes the ecological flow of air in relation to Chinese house styles: "On a hot day, warm air rises up from the courtyard; acting as a convection mechanism, the warm air pulls out interior air from windows facing the courtyard. Windows on the building periphery allow fresh breezes cooled by shade trees (as well as air delicately perfumed by garden flora) to be pumped inside, thus cross-ventilating and cooling down the interior rooms."[21]

The Chinese home did not have furniture such as chairs until the Tang dynasty (618–907 A.D.). Instead, the Chinese sat on woven mats or used low tables. By the time of the Ming dynasty (1368–1644), furniture had been established as a true art form.[22] The types of wood chosen for furniture were as important in the East as in the West. The Chinese woods most used in classic furniture pieces had exotic-sounding names, such as "yellow flower pearwood," "phoenix tail," "chicken wing wood," and "dark purple sandalwood," a form of rosewood that was so dense it would sink in water.[23]

Early ergonomics were found in the design of Chinese horseshoe chairs (figure 2.14). These elegant and dignified chairs encouraged good posture as the rounded arms of the chair allowed a comfortable angle for arms to rest. The footrest at the front of the chair was a simple piece of wood connecting the two front legs for added stability and raised the knees to allow better blood circulation reducing fatigue.

Decorative screens were used for providing scenery in the home, giving privacy or channeling air. Long altar tables, used for ancestor worship, held tablets, urns, and other family heirlooms. Tall incense stands were portable and could be moved from room to room. Wedding cabinets, noodle cabinets, rice chests, and benches were other key pieces of furniture in a Chinese household depending on the status of the family.

The layout of the home revealed the relationship of the people living there. The rooms farthest from the entrance, and hence more private, were reserved for the most important people in the house, whereas the rooms

◀ **Figure 2.12**
Bird and sunflower (1948). (Hong Kong Museum of Art Collection.)

near the front were reserved for children and servants. The Chinese often used heated brick beds and stone pillows. Throughout most of China's history, the family shared beds and baths, and as times changed and old patterns fell away, the shape and use of the house evolved as well. Wealthier families often added additional rooms and courtyards. The tumultuous years in the early PRC saw many homes torn down or reconfigured to accommodate more than one family.

If there was a place in old China where individuality was expressed, it was the garden, according to Kai-Yin Lo, a Chinese historian and designer. She believes the garden reveals the status of the Chinese family living there, whether prosperous or poor, educated or not. The literati used their gardens to vent their frustrations, find solace when things at court went wrong, or find inspiration to write and paint. Chinese gardens were carefully designed and constructed for elegance and simplicity. A seemingly endless water source, low spots, high spots, rocks, and hidden paths were all part of the design. Like Chinese paintings, the vantage points in gardens were many and identified by the placement of objects in the garden and by framing. A round moon gate entryway, for example, was deliberately used to help focus viewers' eye on garden scenes. Garden names were equally interesting. In their book *House, Home, Family,* authors Knapp and Lo mention titles such as "Hall of Distant Fragrance" and "The Humble Administrator's Garden."[24]

Later Influences

The Japanese invasion of China marked a change in the psyche of the people that was reflected in art. Xu Beihong's 1939 painting, a nontraditional piece called *Put Down Your Whip*, is an anti-Japanese street play scene of a woman with a red scarf apparently entreating the Japanese soldiers to stop cruelty.[25]

During Mao's era from 1949 and until his death, items of visual art, crafts, and products were made to support the government's messages. He employed this method of communication when he observed the success of the Soviets in using political images and messages on everyday products.

◀ **Figure 2.13**
Withered lotus. (Xubaizhai Collection, Hong Kong Museum of Art.)

Figure 2.14
Huanghuali horseshoe armchair, seventeenth century, showing early ergonomic fea-
tures. (Courtesy of the Hong Kong Museum of Fine Arts.)

The propaganda in China did not have to compete for attention from other visual messages such as advertising. These posters and artifacts served as prominent visual reminders, and they were often some of the only adornments in an office or home.

The 1950s "Five Haves and Eight Cleans" movement in China was a call to increase sanitation and thereby reduce disease. Knapp and Lo identified the Five Haves as "a family latrine, a covered latrine, a pigsty, a chicken coop, and a cover on the well" and the Eight Cleans were "focused on the house (inside and outside), courtyard, lane, bedclothes, garments, kitchen, bowls, and chopsticks."[26]

Living spaces in China today have changed dramatically from the past. Children now often have their own room. City apartments now resemble Western living spaces. They no longer are designed with the symmetry and simplicity reflecting Confucian ideals.

With China's opening in the 1980s, Western influence was quickly apparent in the arts and crafts of that era. Today's artists and designers have freedom of choice as to whether to engage in the traditional arts and crafts of their homeland or experiment with something new.

Western Influences

The *cheongsam*, a Chinese dress style made famous around the world in films such as *The World of Suzi Wong*, was influenced by the slim Western styles of the 1960s. Thin ties, tapered slacks, and tight-fitting tops had a slimming effect on the cheongsam, as well as a curve-hugging form and a slit to the thigh. These figure-flattering dresses, far from the drab peasant clothes of the revolution, had their start in Mongolian riding attire that required tight-fitting sleeves and side with shoulder fastening closures.

Today artists and designers in China have many outside influences on their work, and the Web is a significant source of information and inspiration for some. Many Chinese artists and designers have studied in or traveled to the West, and when they return, they combine ideologies and images from East and West. Art in China has become expressive and often tests the government's views on censorship, especially items that are critical of the government. Product designs are moving from being master driven, or traditionally crafted, to being client driven in order to sell to global markets. Many artists and designers who engage in the traditional

arts and crafts take up the traditional arts at key art academies and university programs such as the Central Academy of Fine Arts, Tsinghua, Tianjin Academy of Fine Arts, Guangzhou Academy of Fine Arts, and the Hangzhou Academy of Fine Arts.

The next chapter looks at the art and products of the first generation of Mao's Republic. It explores the upending of traditional lifestyles, affecting family, living spaces, work life, personal possessions, and self-expression, in relation to the design and the culture of that time period.

3 The First and Second Generations of Workers in the PRC

There is in fact no such thing as art for art's sake, art that stands above classes, art that is detached from or independent from politics.
—Mao Zedong

The star on the iron in figure 3.1 is an example of everyday objects in the People's Republic of China (PRC) having political messages. It gives the impression that even when ironing clothes, thoughts should be directed toward the vision and advancement of the PRC. Designers and artists in the PRC were called upon to create products with political messages.

The Beginnings

The years prior to the start of the People's Republic of China (PRC) in 1949 were marked by uprisings, famine, revolution, war, and foreign occupations.

The last emperor of the Manchurian dynasty lost his throne in 1911.[2] Other countries that formed an alliance and occupied parts of China during this time looted many of the palaces and temples, and these ancient Chinese relics found their way into private hands and museums in Britain, France, and the United States. Other priceless pieces went with Chiang Kai-shek to Taiwan and with refugees into Hong Kong. As the dynasties and revolutions gave way to the formation of the PRC and old China was gone, so was a large portion of the art, artifacts, furniture, and texts of the past.

The first working generation of Mao's republic, those in their thirties and forties in roughly the time period 1949 to 1969, experienced the excitement of creating a new country along with the hardships of change. Cities and rural villages needed to be built or rebuilt, developed, and organized for the new republic. The years of war and famine had left their mark

Figure 3.1
Iron with a star motif. (From the collection of the China Industrial Design Society Beijing.)

on the people and land. A growing population meant that more people needed to be fed and crop production needed to increase. This was a major issue for the fledgling republic and provided motivation for Mao to work with the Soviets, who were closest to China in communist philosophy and ideals.

Mao set up farming communes as a way to try to create more farming and become more efficient because China had little arable land in relation to the size of its population. Soviet equipment and specialists for farming and industry were brought to China in the 1950s, but the relationship between Mao and Stalin became problematic when they philosophically parted ways. The Soviets left China shortly after Mao and Stalin's plans for China fell apart.

Nevertheless, the Soviets had made their mark in China through architecture, farming, language, and manufacturing. Many of this first working generation of people began to learn the Russian language. Soviet-inspired architecture was built throughout China during this era, and these formal,

heavy buildings stand in stark contrast to the graceful upturned roofs of traditional houses and temples and the mazelike structures of the neighborhood hutongs. Figure 3.2 shows an example of a Soviet-inspired building in this early 1960s photograph.

When Mao's mutually beneficial relations with Stalin cooled after only a few years, the Soviets retrieved their people and agricultural and industrial equipment, leaving Mao with a financial debt to the Soviet Union.[3] Mao nevertheless forged on in implementing new systems to feed and organize the Chinese people. The Great Leap Forward (1958–1960), which was to have China become a self-reliant power by creating its own products, gave rise to the call for the materials needed to make projects for the PRC in newly opened mines and factories.[4] Even backyard furnaces were constructed and kept burning all night to make steel and many metal objects, including household items and tools that were melted in the process.

Figure 3.2
Car in front of a Soviet-inspired building in the 1960s. (From the collection of the China Industrial Design Society.)

Unfortunately, much of the metal produced in these backyard furnaces was of poor quality. Many of the fine art pieces and artifacts made of metal that were not melted down, carted away, destroyed, or stolen in prior years were destroyed during the Cultural Revolution (1966–1976). This movement saw family relationships and friendships end as a result of Mao's desire to break with past Confucian and capitalistic tendencies, which he considered essential for the stability and unification of the PRC.

The Start of the Cultural Revolution, 1966

Gaily colored ceramic figurines of official punishments, beheadings, and "struggle meetings"—gatherings where individuals were openly targeted, shamed, and criticized—were produced and collected throughout China during the Cultural Revolution.[5] The ceramic figurines were used to illustrate correct thinking and behavior and to mark the triumph over the old ways. The figurines depicted landlords, capitalist businessmen, and critics of the new republic in dire circumstances that ranged from wearing signs proclaiming their "wrongs" to being killed.

Thought reform was implemented through local meetings. People who continued to engage in ways not in keeping with the philosophies of the new republic or who were seen as capitalists were shamed in public gatherings. Posters or boards with large writing, or "large character posters," were hung around the necks of the offenders, who were punished in front of local crowds that sometimes turned violent. The victims were often paraded through the streets, beaten, and forced to listen to public accusations of their perceived wrongs.[6]

Old Chinese values and social hierarchies, even those of the family as a unit, began to fall away or were avoided. Ceramic figurines and posters featuring soldiers, model workers, peasants, and Red Guards—youth in China who carried out the Cultural Revolution dictates for change on a national scale—were created to show how the people of the new republic could be happy and productive in their work. The government became the new "family," and everyone, in theory, was considered equal. Women, for example, were now allowed to take an active role in running factories and implementing new government policies. This freed them from their formal duties and subservience to parents, husbands, and in-laws and to become a part of the workforce to build China. This also meant that some

of the traditional crafts related to the home, typically done by women, stopped.

Throughout China in the 1950s, businesses were taken over by the government, and the individuals and families that had owned them lost their livelihoods. Family-owned stores and other businesses built up over generations vanished as individual ownership was forbidden. A Chinese designer now living in the United States recounted how government officials came to his family and told them their pharmacy was now government property.[7] The family name stayed on the storefront even after it became government property.

When living quarters in cities were redistributed, wealthy families lost their homes and their possessions. Where one wealthy family had lived, several families might now be lodged in the same space. In rural areas, many traditional houses were destroyed to create smaller houses for workers. Land redistribution by the central government, however, was thwarted as families were reluctant to give up their family plots they had farmed for hundreds of years.

Rural families eventually formed group communes that could hold up to 25,000 people on thousands of acres of property. The first farm communes set up by the Chinese government were made up of volunteers who were given major support in order to be successful.[8] Their products, living quarters, land, and businesses all belonged to the government.

The products designed during this period were largely created to support agriculture, the military, and industry.[9] Factories were also set up to make agricultural equipment and small quantities of utiliarian goods for daily living, such as the examples of watches (figure 3.3), television sets (figure 3.4), and thermoses (figure 3.5), which were very central to Chinese daily life.

Personal expression in dress fell away as cropped hair, military dress, peasant dress, and mandarin outfits (often called "Mao suits") became the way to show loyalty to the party and the seriousness of the cause. The Red Guards wore khaki jackets, red armbands, and a shoulder bag with a red star.[10] The party message was clear: work and deeds should be focused on the People's Republic, not individuals.

Before the start of the Cultural Revolution in 1966, two Chinese product design professors had the chance to travel internationally. One went to Japan and another to France, where both became aware of the German

Figure 3.3
Watch from the 1960s. (Courtesy of the China Industrial Design Society.)

Bauhaus design influence. They brought this influence back to China, and some early product design had Bauhaus characteristics (figure 3.6) with streamlined and abstract shapes that were similar to those done in Germany.

The Cultural Revolution, 1966–1976

A misconception many Westerners have is that the Cultural Revolution was directed against artists and writers only. Although they were among those persecuted, many others were also affected. The Cultural Revolution was started to crush the old philosophies of China and Western capitalistic ways.[11] Those who were perpetrating such ways of life were the artists, businesspeople, educators, landowners, performers, and writers of that time. Mao wanted to remove those he saw as a threat to his doctrine; he

Figure 3.4
Television set sold throughout the 1960s and 1970s. (Courtesy of the China Industrial Design Society.)

Figure 3.5
Array of thermoses from the 1960s and 1970s.

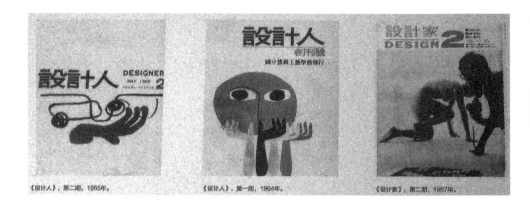

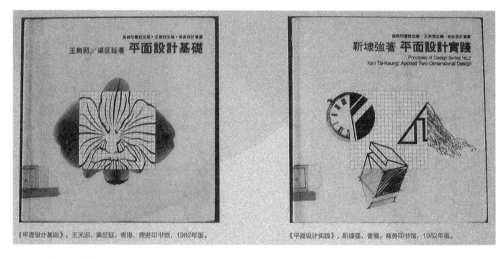

Figure 3.6

Chinese Bauhaus-style magazine covers. (Courtesy of the Tsinghua University 2010 Exhibit on the Bauhaus.)

believed that independent thought and old ways of thinking were stopping the republic from moving forward. During the Cultural Revolution, people who were deemed enemies were publicly humiliated, sent to rural factories or farms, imprisoned, or killed. The atmosphere of fear and restriction severely curtailed art, design, and innovation in China, except those directed by the central government.

Schools and universities in China were closed from 1966 to 1976.[12] Many professors, including those in design education, were sent to farms and factories to be "reeducated" in the correct political thinking of the times. During these ten years, large quantities of art, books, household items, and religious artifacts were destroyed. Book burning and the destruction of living quarters and priceless artifacts, marked some of the activities of the Red Guard and young people who were given free rein to stamp out the old culture.

Mao's second wife, Jiang Qing, led the initiative for the creation of new cultural projects that would reflect the character of the People's Republic. New operas and ballets were written about model citizens. Former traditional artists and craftsmen were asked to make products that carried the Chinese Communist Party message. Those who showed resistance or criticized the party were sent for reeducation or imprisoned; some committed suicide. This was an era of propaganda posters, pins, clocks, books, pen holders, teapots, mugs, flower vases, and ceramic figures that showed Mao, other party leaders, the latest agricultural yield, or military activity.

Propaganda Products

Art and design during Mao's early revolutionary years and the Cultural Revolution took on the look of Soviet propaganda art with its bold, thick lines and muscled workers looking up toward the sky (figure 3.7). Some pieces also featured Mao with themes of elevating workers to high status.

Propaganda posters showed people how they were to live in these new days.[13] Since many Chinese people in the 1940s and 1950s were illiterate, photos were used to illustrate concepts. Posters were used to brighten drab village walls, factories, dormitories, offices, railway stations, and houses. Since the posters had colorful imagery, people kept them for many years. Some people claimed the message was not important and enjoyed the

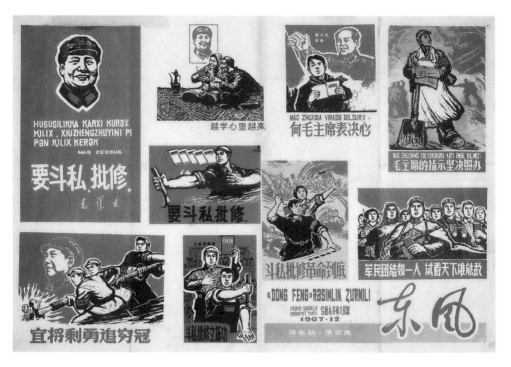

Figure 3.7
Soviet-style red and black block print leaflets. (Author's collection.)

images, but others said they wanted to be just like the people in the poster
and embraced the ideals represented.[14]

The images on the posters often showed strong men and women and
focused on factory, field or military work (figure 3.8). Women in the propa-
ganda images were masculine, sporting cropped hair or pigtails and strong
physiques. This image reflected the equal position that women now oc-
cupied in Mao's Republic and visually helped to undo women's role in the
old society and make way for their new designation as holding up "half of
heaven." The people in the propaganda posters often wore military garb,
workers' uniforms, or peasant clothing. The poster artists searched for what
they felt was the perfect peasant face to model for the images. The mes-
sage was plain, simple, and serious: everyone must work hard for the new
People's Republic.

Slogans for the propaganda posters would translate into an announce-
ment of an accomplishment, for example, "Our Brigade Has Built Another

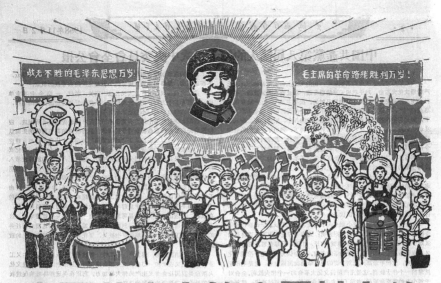

Figure 3.8
Workers celebrating the completion of a job. (Author's collection.)

New Grain Silo." Other posters rallied people together: "Revolutionary Reb-els of the Municipal Technical Training Course, Unite!" In the quest to raise the standard of the peasant class, one poster slogan translates as: "People of the Lower Classes Are the Most Intelligent." The poster shows peasants with blueprints and tools installing new machinery in a factory.[15]

During the Cultural Revolution, posters of Mao were hung everywhere in China and depicting Mao in many scenarios: Mao touring factories, mines, fields, furnaces, airstrips, and docks (figure 3.9). Failing to have an image of Chairman Mao in a home or office was seen as an affront. When his portrait was placed on a wall, nothing was to be placed above it.

Toward the end of the Cultural Revolution, posters began to take on a different appearance altogether in the opening-up period when foreign companies were setting up in China. The posters began to advertise the new products that were available to the Chinese consumer.

The Second Working Generation of the Revolution, 1970–1990

People who came of age at the beginning of the Cultural Revolution are often called the "Lost Generation" because they had little chance of finish-ing their educaton.[16] With schools and universities closed, many children had to rely on what knowledge their parents could pass on to them.

Tang Ming Xi, currently a professor at Hong Kong Polytechnic Uni-versity, was a child when the Cultural Revolution swept through his hometown, an ancient city along the Yangtze River famous in the age of Three Kingdoms (220–265). His grandfather had been friends with a foreign minister and helped to take care of the church in their town. Be-cause of this relationship, his family suffered hardship during the Cultural Revolution.[17]

When local schools were interrupted during the Cultural Revolution, Ming Xi's parents educated him at home and encouraged him to play the violin with hope that he could eventually earn a living as a musician. He was the youngest of four children, and by the time he was of high school age, the Cultural Revolution was coming to an end and the universities began to open. Ming Xi sat for entrance exams and was admitted to a uni-versity. He went on to receive a Ph.D. from Edinburgh University in Scot-land and subsequently worked for Cambridge University in England as a researcher for four years.

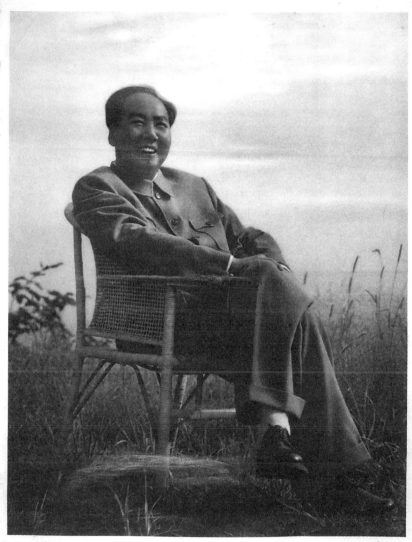

敬祝我们心中最红最红的红太阳毛主席万寿无疆！

Figure 3.9
Mao in a relaxed moment. (Author's collection.)

Ming Xi was fortunate to have been born later in the Cultural Revolution than his siblings. Because he was younger, he had a better chance for a university education when they did finally test for scholars and open the universities again. His family fared much better when economic reform started in late 1970s with good employment opportunities, and this coincided with the chance for Ming Xi to enter the university and ultimately study overseas.

Many children witnessed the struggle of their parents and other family members in the early years of the PRC. By the second half of the Cultural Revolution, chaos and fear were common in society. This was not an era where individuals could express their opinions or produce art or designs that did not support the Communist Party. Since literacy was low in China at this time, most people got their information from local meetings, propaganda posters and artifacts, or radio.

The little red books associated with Mao Zedong's thought started out as blank red books where Communist Party thoughts and philosophies were recorded during local meetings. Later they were printed with quotations from Mao. Red Guards were often depicted in posters and ceramic figurines holding the red book high, while dressed in the People's Liberation Army fatigues, red armbands, and caps with a red star and carrying "Serve the People" bags.

A second-generation woman in Shanghai recounted her 1977 wedding ceremony, saying she wore a new black and white striped sweater. The only other sweater she had was an old one her sister had given her when she was assigned to work on a farm. Their wedding gifts that year were a wash basin, a water flask, a bed sheet, and a sweater. After their marriage, they lived in a 237-square-foot room, considered spacious for that time in Shanghai. They had a bed, an old table, two chairs, and some old quilts. She saved for an entire year to buy a chest of drawers. They could not afford a cupboard because that cost 196 yuan and therefore was out of the financial reach of many who were starting a household.[18] Ration coupons for food and products were common during this time, and consumerism was extremely limited. In the 1970s, the products most people wanted were a refrigerator, a TV, a tape recorder, and an electric fan.[19]

Many of the second generation, those now in their sixties and seventies, became comfortable with their government telling them where they would live, what they would eat, where they would work, and what they

could buy. Some enjoyed the lack of pressure that comes from not having to provide for everything and having low prices. This generation did get to experience more changes later in their life that allowed for more personal freedoms and consumerism.

After Mao died and Deng Xiaoping rose to power in 1978 after being rehabilitated in the countryside for having capitalist tendencies, he began to overturn many of Mao's policies. Through reform of these policies, peasants were allowed to farm their own plot of land, and industries sprang up that were government owned and sanctioned.[20] Deng realized that China needed money to stimulate the economy. He led the "Reform and Opening Up Period" in the early 1980s, when he became famous for sayings such as, "It doesn't matter what color the cat is, as long as it catches mice," and, "To get rich is glorious." If Chinese people got rich, that it was a sign of prosperity for the nation.

Deng believed it did not much matter how to get a better economy, because the important thing was for the economy to improve. His opening-up era allowed young scholars in China to learn from the success of those in developed countries. He also allowed some international companies to enter China for the first time. Kentucky Fried Chicken and Coca-Cola were two of the first American companies to enter China. By the end of the Cultural Revolution, primary and secondary schools began to open. A few technical universities had stayed open during the Cultural Revolution, but the major universities remained closed until 1976. It was during this time that the first design departments were established in universities in major cities in China.

Anyone with a high school diploma could take university entrance exams, and more than 11 million candidates did so in November 1977 and the next summer. Candidates included factory workers, farmers, fishermen, former Red Guards, and urban youths who had been sent to work on farms. Chen Zhangliang, a prominent Chinese scientist, recalled that time and why it was a turning point for those accepted into the universities. In reference to getting an education, he said, "My teacher said it was the difference between wearing grass shoes and leather shoes."[21] In 1978, fifty-two Chinese students went abroad to study. In the next decade, thousands studied in Australia, Canada, the United Kingdom, the United States, and other countries. Very few graduates returned to China directly after their overseas studies in those early years, choosing to work in their temporarily adopted country.

The opening-up era, which signaled new freedoms, had a direct effect on the fine arts.[22] In 1975, the first active underground artists formed the No Name Group. They held their first private exhibition in 203 Big Yard, a home owned by artist and member of the No Name Group, Zhang Wei. In 1979 the "Twelve Artists from Shanghai" exhibit opened. In Beijing later that year, the No Name Group held an avant-garde event that the police shut down. Nineteen-eighty-five saw the beginning of the 85 New Wave Movement, which signaled a new era in Chinese art that was "was neither western modern nor historic Chinese."[23]

The Opening Up and Its Effect on Design

The effect of the opening-up period on design in China was significant. By 1981 the China Art and Crafts Association had been established, followed the next year by the China Packaging Technology Association and, in 1983, the China Advertising Association.[24]

Modern graphic design in China had much of its start in Shenzhen with influences from Hong Kong. Designers who worked for state-owned companies began to create posters on their own to enter design competitions or promote their own ideals. Graphic designers began to open small studios but were still reluctant to let go of their permanent jobs because entrepreneurship was not yet supported by the commercial community or fully allowed by the government.

Hong Kong provided ideas and opened doors to the West through its manufacturing base. Many of the Hong Kong manufacturers moved their factories to the Pearl River Delta and began to take production orders from the West. In the factories the designers were introduced to products that they had never seen before. Designer Wang Xu, who worked for a state enterprise at the time, came to Hong Kong in the 1980s to interview designers for *Design Exchange* magazine.[25] In this early design magazine he wrote about overseas Chinese designers, opening the world of the local designers to experiences of their international counterparts. He also spent time with designers in Hong Kong and was influenced by the work of well-known Hong Kong–based designer Henry Steiner who produced a *Design Exchange* cover for Wang Xu (figure 3.10).

Steiner, born in Vienna and raised in the United States, was one of the first people to work in corporate design in Hong Kong. He had studied at

9

d e s i g n

e x c h a n g e

German
Graphic
Designers

Kazumasa Nagai

Figure 3.10
Cover of early *Design Exchange* magazine designed by Henry Steiner. (Collection of
Henry Steiner.)

Yale with Paul Rand, one of the originators of the Swiss style of design, and
earned a fellowship at the Sorbonne. Arriving in Hong Kong from New
York in 1961, he found only a handful of commercial artists already there.
He became one of the earliest major influences on young graphic designers
in Hong Kong and throughout the rest of China in this era. He apprenticed
many designers in his practice and is often called the "father of Hong Kong
design." He contributed professionalism and international standards of
corporate identity, architectural graphics, packaging, and editorial design

to the region with major clients such as Citic Pacific, Hilton Hotels, Hong Kong Jockey Club, HSBC, ShanghaiMart, Standard Chartered Bank, and Unilever (China). Many of Steiner's designs grace the top of Hong Kong's tallest buildings, such as that for HSBC (figure 3.11). Steiner's multicultural perspective eventually led to his coauthoring with Ken Haas the seminal *Cross-Cultural Design* based on his experiences.

Deng's opening-up period was the start of a growing consumer market, free trade, and increased personal expression and freedom. Guangzhou, Shenzhen, and the southernmost part of China were designated Special Economic Zones. Factories in these towns were allowed to work for Western companies, and some Western companies were permitted to set up joint manufacturing concerns in the Pearl River Delta early (PRD) as it was a Special Economic Zone (SEZ).

Toward the late 1980s and 1990s, Hong Kong factories moved from cramped spaces in their home territory to larger areas of land in China.

Figure 3.11
Steiner's logo for HSBC. (Courtesy of Henry Steiner and HSBC.)

Since Hong Kong had begun to manufacture products for the rest of the world, this Western influence was carried across the border when the factories moved to the PRD. Chinese factory workers learned to make everything from clothes, handbags, furniture, phones, toys, jewelry, watches, and more for the West. The army fatigues and Mao suits they had manufactured in the past were soon replaced by leisure suits and blue jeans.

Many state-owned companies that started in China in the 1960s and 1970s became stronger in the 1980s and 1990s. The Chinese government provided financial support, and returning graduates brought new ways of working to the management teams and factory floors. Excellence in manufacturing and lower costs in the PRD resulted in an influx of Western companies that were moving their manufacturing operations to China.

There was a downside, however, in relation to the budding innovation that started in China at this time. Projects that were started in China were stopped in some companies in order to take on manufacturing projects for the West. Although this brought profits and expertise into China, local innovation was curtailed or put on hold. Xin Xiangyang, dean of the School of Design at Jiangnan University in Wuxi, recalled the time that work on one of the largest airplanes in the world in China was stopped to make doors for U.S. airline manufacturer Boeing. Had the work been ongoing, he said, the airplane could have been a major product early in the airlines industry, possibly rivaling other airline manufacturers today.[26]

One of the design firms in Hong Kong during this time was headed by Kan Tai-keung and Cheung Shu-sun. Freeman Lau, a young Hong Kong designer from the Hong Kong Polytechnic University School of Design, joined the firm in 1988, and in 1996 the firm became Kan and Lau Design Consultants. Lau remembers the first time he saw the work of Kan Tai-keung and how deeply he was affected by a poster containing a Chinese brush and a ruling pen, which seemed to balance the exchange between Chinese and Western cultures. Freeman's own early work also had an East–West aspect that reflected the culture of Hong Kong at that time.[27]

State-owned companies and universities on the mainland during the 1980s paid low salaries, so workers were allowed to have second jobs. Many graphic and interior designers during this time did their most creative work in their second jobs. They could enter competitions with posters or interior designs they produced on their own, which meant they had more creative

control over their own work than they would have in state-owned companies. Small advertising agencies were set up by groups of designers from the Guangzhou Academy of Fine Arts. Small design consulting firms began to appear in Shenzhen and Guangzhou, and then farther north in Shanghai and Beijing. Modern design was beginning in China in earnest.

4 The Third Generation

China's third working generation is the link between the old and the new. Now in their thirties and forties, they are feeling pressure to do their part for China and themselves. Their parents and grandparents helped build the PRC, and now it is their turn to see their country be successful.

Born in the 1970s and 1980s, this generation reaped the benefits of Deng's opening-up period and had access to education at home and overseas. This generation, a mix of communism, capitalism, and Confucianism, is sorting out their lives through their peers, what they search on the Web,[1] and PRC government direction. Later members of of this generation are sometimes called the post-1980s children—the ones who were the first to feel the effects of the one child policy and the Western influence from Deng's opening-up period.

Many of their parents were persecuted in the Cultural Revolution. Their hope was for their children to get an education, something that was often impossible for this "lost generation." Now, with education credentials in hand or factory experience behind them, this third generation of the PRC is pioneering a new lifestyle in China, creating a cultural evolution.

Many of the third generation saw their parents harmed and humiliated. These children were often sent with their parents to work in distant parts of China while their parents were reeducated with thought appropriate to Mao's doctrine. After the universities reopened, many took the opportunity to study. Others went to work in state-owned companies or stayed in rural areas to farm.

Today the third generation knows they have the opportunity to take control of their own lives, and in many cases, they actually have no choice. The government, which is encouraging privatization of businesses and entrepreneurs, is not providing everything as it did before. People who want

a house or car must buy it on their own. For most, this means unending hours of education and personal development to compete for the best jobs. The hours of education and work in China are high because of the competition. While this generation may attend a university or work, they must constantly upgrade discipline knowledge, language skills, work skills, and social skills in order to compete. For many in this generation, it means going without and feeling left behind.

Nevertheless, this third generation has more personal freedom than any of the earlier generations of the PRC. If they have appropriate resources and social status, they can choose where to live without waiting for government housing to be available. Gone are the drab Mao suits; they wear what they like. Travel restrictions have been eased, and if they have the means and time off, they travel. Although China is still highly competitive for university placements and job opportunities, they have more education opportunities than both generations past. They are living a new Chinese dream, and with their government's approval.

But many pressures go along with these freedoms. This generation has had to learn how to become educated, purchase housing and transportation, and negotiate work life and personal life. Many are only children, and they feel pressure to spend more time with their aging parents and grandparents. Migrant and urban workers of this generation have become the sole financial support for their family, which may include grandparents, parents, and children.

Other pressures come from the new work ethic: dress well, have a nice home and car, make more money, and have a family. The expectation is that by the time they are thirty years old, they should have determined what their life will be about, which dates to Confucian ideals for what should be accomplished in each decade of adult life. But trial and error in the workplace due to poor decisions, missed chances, and other life issues can get in the way of becoming settled by age thirty in today's China.

Not everyone in China has the same advantages. Migrant workers are classified differently than those in cities or rural villages, and this status affects the quality of their health care and education benefits and those of their children.[2] Movement from province to province is difficult because people are still registered as city or rural inhabitants, and this classification is not easily changed. The benefits are tied to the classifications, and the

classifications are tied to the provinces. A Chinese province can easily be overwhelmed with millions of migrant workers who need benefits that are not available to them.

Those who had no education as children and are illiterate have very few opportunities to leave their village to work in cities. A twenty-year-old young man in a Yunnan village was depressed over his lack of opportunities because he had no education and there would be no job for him in a city because he did not know how to read. He saw his days beginning and ending in the small village.

The One-Child Policy and the Opening Up

Two major events significantly changed to the life of those the third generation: the one-child policy and the opening-up policy. The CCP had been supporting the one-child policy since the early 1970s but was lax in enforcing it in rural areas as more children can help farm. The impact of the one-child policy was a rise in the standard of living for most Chinese by allowing more mobility for parents to go where the work was or get an education. This coincided with new work opportunities as foreign manufacturing came to China in the mid-80s.

The PRC had been closed to the West for many years, but by 1988 Western corporations were partnering with Chinese companies. Deng explained his bottom-line orientation and lack of reverence for a strict Communist ideology in this way: "'It does not matter whether the cat is white or black; if it catches mice, it is a good cat.' That 'good cat' was capitalism."[3]

The PRC allowed foreign companies to partner with existing state-owned enterprises. Western companies, attracted by cheap labor, manufacturing options, and sourcing opportunities in China, shut down factories at home and moved their operations. When the Shenzhen and Guangzhou Special Economic Zones opened across the border from Hong Kong in the early 1980s, hundreds of Hong Kong manufacturers, along with a few Western companies, moved their factories into the Pearl River Delta region to take advantage of the low labor costs as well. This was their opportunity to build newer, more spacious facilities than those at their cramped sites in Hong Kong. U.S. manufacturers saw moving offshore as as a way to avoid labor unions. The third generation, now beginning to move into the workforce,

found jobs making consumer products that ranged from expensive leather goods, watches, jewelry, fashion, and gift items to inexpensive toys, batteries, and household items.

At the beginning of privatization, many people started their own enterprises on the side, working in the evenings at a second job. The first returning scholars from overseas, dubbed "sea turtles," added another layer of expertise in business and manufacturing.[4] They found work in state-owned enterprises or Western firms, or they started their own businesses.

The third generation has experienced all of these changes: the excitement of the new, confusion of the present, and conflict from the past. This stimulus of privatization, in conjunction with the one-child policy, changed the makeup of the Chinese family, made it possible for rural workers to become urban dwellers and changed purchasing patterns and shifts in provincial economies. It became much easier for parents to move with only one child, or to leave their child with grandparents while they went to school or worked in the factory. These opportunities were a stimulus that produced ambitious, bright, industrious, and creative people who were ready to move ahead in a new PRC.

Sea Turtles

These returning scholars have been lured back to China by good jobs, good salaries, and the chance to be near their family and culture. In some cases, they have an advantage over those who did not study overseas, especially in businesses where Western knowledge is desirable.

Many who return are surprised to see the changes that have rapidly taken place in their cities and villages, their governmnet, and their culture. The hutongs, old neighborhoods with small alleys, have been demolished and replaced by high-rise apartment buildings; and new roads have paved over fields; and private companies have replaced many state-owned enterprises.

The sea turtles have found a new middle class that is expanding and enjoying arts and sports activities. Even second- and third-tier cities, along with towns and villages, aspire to have arts and local culture in their environment. Those who studied overseas and understand Western ways of working and living have come back to China expecting to effect change. But Western work styles do not always fit with the Eastern work culture and are not readily accepted. These sea turtles find their skills are wanted but

their advice is not always welcome. Those who studied overseas will need to be patient to see some of their ideas adopted by their management.

Tao's Story: October 6, 2009

Tao Huang, a thirty-four-year-old design professor living and working in Chicago, talked about her education at the Guangzhou Academy of Fine Arts and her early years in design in China.[5] She said the mix of Western and Chinese influences fed her creativity and education. Tao and her peers were educated in the Bauhaus method, a Western model for design education, but the Chinese market was not ready for these changes. This was in the 1990s, and the opening up had just started. She said:

The students didn't understand the market they were supposed to design for. A lot of my colleagues went into advertising. I did interior design, but they would make that free for the cost of construction. Unless you had a well-established design firm, they sometimes wouldn't pay you. In advertising at that time, the money was much better. We did postproduction but still didn't make much money. We knew computing and animation, which was how we got the jobs to begin.

Back then, management wouldn't hire someone over thirty, especially a woman. Students tried to finish school by twenty-two so they would be able to get a job as early as possible. Managers were often replaced by younger people because they had the new skills. It was the latest computer skills that were valued more than experience, except maybe for creative advertising directors. There was nowhere else to go, so many people had to become entrepreneurs. Also, the person who had the clients could stay in the advertising agencies.. *Guanxi* [friendship, connections] was everything."

We didn't understand our own market. It was more complicated than we thought. We just knew the big cities, not second-tier cities or villages. China was too diverse for stores like Target or Kohl's. A lot of designers did what I call "rogue design," or knockoffs of local designers. They weren't proud, but they did it and would have about a week to do so. Designers are commercial; they didn't see the value of exhibiting their work in an art gallery at that time. They didn't find value in it. They wanted to make money, and they stayed away from politics. After the 1990s, the students tried to rebel. They would do silly things like take photos in Photoshop and manipulate them for fun. Design moved from manufacturing to design and innovation and service. Manufacturing was at the bottom.

Tao continued:

But what is design in China? Some talk about the neoclassical Chinese, simplifying icons, language, and symbols. The classic products are high priced and selling, but

good Chinese mass production of regular products is not there yet. Less than three or four of my classmates are doing product design.

I was not challenged by the students when I taught in China. I would catch the students looking at my face to see what the right answer was. I wanted to know what they thought. They try to find the right answer, not to solve the problem. Design should not be judged by the teacher, which is what would happen. The students would then be limited by the teacher's expertise. They need to know how to push and judge on their own, but it's a cultural issue. The innovation in China right now is superficial. The students are trained in market research and can do that well, but they cannot look beyond. It is always very practical stuff, difficult for them to see the blue sky. The students today are more self-centered and more individualistic.

The people in China have more freedom but are still under control. You can't play around with anything to do with the party or leaders. People self-censor, too. With the Internet, people are more willing to speak up, but China just shut down a site. It always plays on one's subconscious: Will it invite trouble for me? The culture enters your subconscious, and so you start to accept.

New Freedoms

Within reason, this third generation has the government's permission to become financially successful, creative, and innovative. No longer told by the government what they would be studying and which profession they would arrive in, the third generation has been allowed to make personal choices. If their families had the financial means, they were able to choose what and where they would study. If they wanted to be computer specialists, economists, or lawyers, they could. Many families sacrificed much to send their only children to schools that were out of their financial reach, but education was crucial for better-paying jobs. For those living in rural villages, education was the only way for them to leave the village and prosper. The other option was to leave the village and work in one of the thousands of factories in the Yangtze or the Pearl River Delta.

Arranged marriages in China are a thing of the past. Everyone has their own personal lives and relationships. Members of this generation are making their own decisions about a partner or spouse, whether to get married, and whether to have the one child allowed married couples. They can choose to buy an apartment or rent. They can save their money or buy new clothes, buy a car, or take a vacation. These freedoms are new to China. Prior to the birth of the PRC in 1949, Confucian culture dictated societal norms, leaving little personal freedom.

Many in the third generation do not turn to their parents for advice because their parents grew up with very little and had many decisions made for them. So instead they turn to their friends or the Web for advice on buying and selling an apartment or buying a car, for example.

Much more than the previous two generations, this one has experienced the the rebirth of culture and art. Fine art, film, dance, literature, poetry, and music have begun to flourish again. The range of creative expression is apparent in the larger cities, and the audiences are sophisticated enough to appreciate the new work.

Entrepreneurs are welcome in this generation. Fei Liu, whose grandparents were senior officials in the Communist Party and father was a local politician, is a jewelry designer. His grandfather's passion for Chinese opera inspired him, and at age five, he began painting.

Stories of the spending habits of the newly wealthy are always met with surprise. Ten thousand U.S. dollars for champagne for an evening or a Bentley ordered in a special color fill the pages of national newspapers alongside stories of how corrupt officials have made their wealth. But as a result of their hard work and excellent eduction, the middle class is rising, and they look forward to a great life of financial prosperity, a smart, well-educated child, and a comfortable home.

New Pressures

Money is now needed for everything the government no longer provides: living quarters, transportation, clothing, groceries, health care, and other basics of daily life. Advertising, which was not prevalent in the past, is now visible everywhere, reminding the Chinese people of what they do not have or what they should have: vacations, cars, high-tech products such as high-end TVs, cell phones, and luxury items. There is pressure to look good. Today's individual beauty practices have replaced the "revolutionary beauty" practices of the past, drab Mao suits, and utilitarian hair styles.[6]

Although it may seem that the life of this third generation is much easier than that of their parents and grandparents, these new freedoms have brought stress with them. These only children need to take care of their parents in their old age. They need to sort through health care issues, old age issues, living space, and assistance for their parents if they do not live nearby. This generation, pulled by long work hours, their spouse, and

their child, feels guilty when they cannot spend enough time with their parents.

Making enough money to pay for a home, an education, and health care has become the focus for the third and fourth generations. But many rural workers in the third generation will never have an opportunity to better their station in life. Maureen Fan, of the Washington Post Foreign Service, writes "that money now takes precedence over family has long been an unspoken fact of life here, but it is a view often obscured by the popular notion that Chinese are, above all, family focused and family-centric."[7]

Benny Leong, a professor in the School of Design at Hong Kong Polytechnic University, has been conducting major research through his Asian Lifestyle Lab. He and his team have visually documented the lifestyles of people in the various provinces in China. His reasearch is a study in daily Chinese life in first-, second-, and third-tier cities. The visual documentation allows for analysis of lifestyles in relation to home life, socializing, and work life. Figures 4.1, 4.2, and 4.3 show a typical middle-class household in a second-tier city.

Many of the rural poor who migrated to work in factories have left their children behind with their grandparents, who are not always fit for helping with studies or discipline. An estimated 20 million rural children are being raised by someone other than their parents, who are migrant workers. This leaves some grandparents resentful of their children who now have apartments and cars in the cities and rarely visit their children and parents. Others are more tolerant, knowing what their children must do to provide for them and their young charges and carve out a living in the city.[8]

At the same time that they are focused on the future, many of the third generation worry that traditional Chinese crafts and culture of old will be lost after the older generation has gone. Some are working to save traditional skills. Liu Bin, who runs Three Stone Kite, makes kites from a craft that his grandfather and great grandfather perfected. This craft was well respected by the nobles in imperial China but lost its appeal when the Qing dynasty collapsed in 1949. Liu's grandfather had to give up kite making as a profession and became an employee of a state-owned department store. For thirty years, he did not sell a single kite, but he continued to make them for a hobby. In the 1980s, after retirement and the opening-up period, he began to make them to sell to foreigners. Liu's classmates from fine art school ask him why he did not just get a comfortable job in an information

Figure 4.1
Middle-class kitchen with ubiquitous rice cooker. (Courtesy of PolyU Asian Lifestyle Lab.)

technology company and work on Web sites. Liu, who grew up with his grandfather, decided to take over the kite shop because he was worried the craft might be lost.[9]

In one sense the the mainland economy and society have not changed: as in the past, women look for security through their partner's position at work and socially. Foreign husbands were considered desirable until the economic growth in China took place and Chinese men were able to make salaries that were attractive to Chinese women. Thus "mixed marriages" have slowed as women look for an "economically fit man. These are men who have stable but unglamorous profession jobs, like teachers and engineers, which make them less likely to become victims of the recession."[10]

Yet personal choices have also led to personal growth in many cases where this generation needs to grapple with the choices they have made, especially in relation to an unhappy marriage. Prior to the the founding of the PRC, most marriages were arranged by families, and divorce was

Figure 4.2
Interior living room with sculpted ceiling and oversize furniture. (Courtesy of PolyU Asian Lifestyle Lab.)

extremely rare. Marriage, and a satisfying relationship with a partner are fairly new concepts in China, but of course they are not guaranteed by choosing one's own spouse. In an article on her café in Beijing, owner Wu Yelan said that her customers, who are well educated, seem to be lost in many aspects of life: "Let's take those born in the 1980s as an example. They are pretty lost and disillusioned about love and marriage because they don't have role models to look up to. Their parents, mostly born in the 1960s, can't serve as good examples as many of them didn't marry for love. Many got hitched after being introduced by senior colleagues."[11]

This third generation has difficulty maintaining relationships, some say, because they were spoiled as children or their parents had to attend to the family's economic needs rather than emotional needs. Others point to the the fact that their parents or grandparents may not have had happy marriages or other satisfying relationships. And some believe there is a breakdown in family and Confucian values that expressed moderation, close

Figure 4.3
Technology is king. (Courtesy of PolyU Asian Lifestyle Lab.)

families, and obedience. Gary Xu, a former Red Guard in the Cultural Revolution and now fifty-five years old, said, "You will never ever find any trace in this [new] generation of how we felt in the old days; guys didn't even dare touch a girl's fingers before marriage." Premarital sex, he said, could have cost them a good state job or a place in a university.[12]

Many couples today who do marry have decided to stay childless. They see couples, sometimes called "child slaves," who struggle to provide for their child's education, medical insurance, and housing. And some couples who would like to have a child have "decided against having any of their own because of insufficient social welfare protection for child care, health, education and housing, as well as the lifelong reality of harsh competition from preschool to the job market." The birthrate in the PRC dropped from 21.06 babies per 1,000 people in 1990 to 12.1 in 2007.

Migrant workers and others often need to pay all medical costs for their children's treatment. Many couples who opt to have a child find themselves needing better housing to be able to enroll the child in the better educational systems that are tied to particular neighborhoods, which often

have higher housing costs. Their mortgages also put a strain on finances and relationships, often resulting in couples becoming "house slaves" as well.

A 2009 *South China Morning Post* article on the wealth gap shows that an urban household's average income as 14,213 yuan and and that in rural areas is 4,306. Spending on entertainment by urban dwellers is listed at, 1,185 yuan and rural spending on entertainment at 243 yuan. More telling for China's future are statistics from 2008 on the number of undergraduates per 100,000 population: the figure is 6,750 for urban residents in Beijing versus 969 in Guizhou, a province in southwestern China.[13] The PRC government is working to close this gap: 17.5 percent of the 2010 national budget was targeted for rural development.

Liu Wei, a farmer's daughter, knew the only way out of a future of backbreaking labor was to get an education that would take her out of her village. Her dream was to move to a city after her studies and find a decent job that would let her pay back her parents. Her mother, who cannot read or write, now cries every day because Liu Wei killed herself when she could not find a job after graduation.[14] The fourth generation—those in their teens and twenties—are feeling the same pressure in all areas of life: education, work, relationships, and family.

The summer of 2010 found Foxconn, a Taiwanese firm that manufactures electronics, at the center of a tragedy where eleven workers took their lives by jumping from the top of the factory building. Inquiry by officials noted the prison-like atmosphere, difficult working conditions, and lack of social life for the young people who migrated to work at Foxconn. As in other countries, suicide is an outlet for those who suffer from loneliness, poor working conditions, and difficult relationships. In China, young people who believe they have failed or brought shame on their family in some way find it difficult to go on. In 2007, the first national suicide prevention center was opened in Beijing. Many other suicide centers have opened on university campuses and in larger cities.[15]

Yet another pressure is that private lives are becoming less private because of censorship and surveillance. The Chinese government has increased the number of Internet spies to check daily blogs, Web sites, and text messages sent among private citizens. An interesting aspect of this is the Chinese government's announcement of this increase in Internet censors. With 1.3

billion people to oversee, instances of unrest are important to know about, and the government finds the best way to do this is to monitor Web sites and blogs. The average Chinese citizen who has a Web site must register it to identify ownership. An article on texting and private lives notes: "China Mobile, the mainland's largest mobile phone operator . . . would suspend text-messaging services to mobile phone users in Beijing and Shanghai who are found to have sent messages containing 'unhealthy' content. Although the operator didn't define 'unhealthy,' it usually refers to messages containing sexual content."[16] Some young texters have purposely sent messages to test the extent of what is considered unhealthy, while others texted funny messages about cracking down on "unhealthy" produce such as cucumbers and carrots because of their suggestively "unhealthy" shapes.

East-West Communist Confucianism

"A melting pot of ideology" sums up the third working generation of China. They take pride in their government and country but also in China's capitalist ascendancy in the world. The gap between the rich and poor exists, as it does in many other countries, but China is now far removed from Mao's ideals that everyone is equal, a painful situation for those who feel left behind or disadvantaged.

In the late 1970s, advertising began to replace political posters and newspaper messages, and political messages moved to television. This third generation has watched ads and messages for toothpaste, cough syrup, watches, and other Western goods. Packaging for products, rather than the wrap-and-tie method of the past, was starting to fill store shelves touting the product's benefits. In the 1990s, the authors of *China Design Now* wrote:

For Shanghai's urban middle class, material consumption and personal achievement were important symbols of a newly acquired social status. The status symbols ranged from the modern Chinese concept of the Four Great Things (represented in contemporary society by the house, car, computer and mobile phone) to success in education, at work, in marriage and in health.[17]

Design and marketing research from the West does not easily translate to the East. Focus groups, surveys, and even interviews are less useful in

China in the way Western researchers may want to use them. It is very difficult to get particular information if you do not know local people or find people to interview through friends and connections. Many people in China do not let foreigners into their home and feel that they might answer questions incorrectly or in a way that may cause problems to themselves or someone else. Observation is limited as well because cultural differences may skew findings.

The changes in society are in flux. The old Confucian hierarchy and the Communist ideas of equality have faded. Those changes have taken China far, but more changes are needed. *Megatrends* authors John Naisbitt and Doris Naisbitt wrote, "In the old China, obedience was of high value, and a subordinate working class served very well in China's first state as workshop of the world. But what will drive China into the next stage—the creation of distinctive Chinese products and design—will be the spirit of non-conforming, talented, creative artists and intellectuals."[18] Continuing this view, they write, popular culture is coming back to China. Award winning films, popular music, fashion that represents the new youth, and many other signs of new cultural works are coming. This is a huge change from the culture of the past in which the Confucian ideals suggested little change. Art has been strongly influenced by respect for China's history. It has not been a matter of creating something new but a matter of staying in the traditions of the past."[19]

Propaganda is still prevalent in China but in a different way from the past. The authors of *China Design Now* believe that propaganda posters have not disappeared entirely from the public but have moved to electronic media and that the "partymercials" and "indoctrainment" pieces look like their commercial counterparts.[20] Through speeches, newspaper articles, and other forms of communication, party officials spread the views of the Chinese Communist Party throughout China.

The third generation is caught between old and new beliefs, old and new generations, old and new economies, old and new personal expression and development. In addition, the societal belief in China is of working in harmony with a group, sacrificing oneself for the sake of others, and being humble about personal accomplishments. But this generation is now expected to become successful by promoting themselves and their skills and supporting their family after competing in every area of life: schools, jobs, partners, and their place in society.

Me and Mine

Members of the third generation with newly found wealth flaunt their good fortune, and their quest for luxury goods, better apartments, racy cars, and high heels goes unabated.

A research study conducted in China by Steelcase, a top American office furniture and worklife company, proved insightful. The Steelcase team learned that the post-1980s generation expects employers to provide opportunities and guidance on the job, and they are not afraid to leave a job and pursue better opportunities.[22] This, coupled with the belief that continuous learning and fair compensation are more important for their careers than security, means that Chinese companies may experience rapid turnover but will also benefit from the skills that new workers bring to the company. Competitiveness among companies is good for career positioning, and it is heating up the Chinese workplace.

The Steelcase China study also showed that work life today is more focused on individual needs than it was in the past. Young workers believe socialization is often more important with friends than family, and they want a clear boundary between work and the rest of their life. In addition, they feel responsible for their company's image and success. They value a feeling of accomplishment, are globally aware and socially networked, and they value their independence highly.

Chen Mann, a fashion photographer and contemporary artist who does visually fascinating work, says, "We are more materialistic, more keenly sensitive to our personal states, probably because we've all been the single child and treated like precious beings. We are selfish but at the same time confident about expressing ourselves in distinctive ways. We cherish our individuality."[23] Writer Vivian Chen points out that Chen Man's images show modern Chinese women to be "sexy, strong and independent-minded." She also believes that many people in their thirties in China are more concerned with their own life than with politics.

Xue Xinran, author of many fiction and nonfiction books on China, has tried to encourage the elders of China to talk about their history because, she maintains, many young people do not believe the Cultural Revolution took place. She explains: "I ask so many of the older generation why they don't talk about those things. They say, 'It's our culture to never mention this. We don't want to pass on something so painful to the next generation.'"[24]

Leslie Chang, author of *Factory Girls,* believes the women in factory areas, who make up about 79 percent of the entire workforce, are the real heroes of this generation because they have helped China improve its economy steadily. These young women left their villages to work long hours on assembly lines, all the while preoccupied with getting ahead, developing better skills, and finding a better job.[25]

Self-expression is coming of age in China. This generation writes, sings, designs, and creates from their personal thoughts and feelings. But those who criticize the government through their art, design, writing, or film may find themselves in trouble. Inciting unrest or creating work seen as undermining the government in any way is a serious violation, and self-expression in this area remains dangerous.

While government censorship is increasing in some areas such as the Internet, and what is appropriate to say is becoming more closely defined, many believe it is not worth risking their life or livelihood to discuss topics the government does not approve of, so a form of self-censorship takes place. Nevertheless, there are people in China who are critical of the government, very visible, and speak their mind, testing the limits of the government.

Recently, waves of strikes in factories throughout China have threatened harmony in both rural and urban areas. Although these strikes have resulted in purported improvements for the workers, they have caused problems for factories that are only getting by. In addition, uprisings over land sales by government officials to developers occur frequently throughout China.

As Tao Huang has indicated, the people of China must begin to understand their own markets, no matter how diverse they may seem. It will be a natural evolution for Chinese companies to create brands for their own markets tailored to those who can afford their products. As we will see in the following chapters, the new creations in Chinese fashion, housewares, and media are of high enough quality to be attractive to the global market and show the strength of an Asian aesthetic.

The third generation is educated and financially stable, and the government is on their side supporting this new lifestyle by providing expanded educational institutions, business parks, and some assistance for growing new companies. Their future is bright, and the hope of the government is that this generation will create a difference, and possibly a turning point,

for China as a global leader. Whether this generation moves forward in a positive way or buckles under the care of parents, uneven economies, or unforeseen changes from the government remains to be seen. My guess is that this third generation will make significant contributions to China's future through the creation of new brands, companies, social solutions, and entertainment that will charm the rest of the world.

5 Brands, Trends, and Product Development in China Today

The Chinese people today are relatively new consumers. As little as twenty years ago, the majority of Chinese people could buy only products made in government-run factories. The simple Communist-produced goods were all they knew. One fifty-year-old woman, who is now enjoying an abundance of products in her second-tier city, said, "Even if you had money, there was nothing to buy." As late as 1989, most goods were wrapped in paper and tied with string. There were two types of shopping systems at that time: one for tourists and one for local people. The local people always wanted the Chinese currency that was reserved for tourists because it offered more choice of products and was "worth" more. The only way the China natives could get this other currency was to trade with the tourists, or it was just given to them by tourist friends leaving China.

Today's Chinese customers are quickly learning about consumerism, as compared to the decades Westerners had to learn about purchasing, marketing tactics, and brand strategies. Western marketers groomed consumers over many years, targeting them with messages about brand loyalty and instilling beliefs in their products and services. Basic ways to purchase, such as in-store monthly layaway plans, credit card discounted items, and the myriad varieties of discounts such as "buy one, get one free" are new in China and are not common throughout the country.

Western markets differentiated the role of retailers from high-end to low-end large-volume discount warehouses. Americans have become used to the differentiation of products offered in Target, Kohl's, JCPenney, Macy's, and Bergdorf's. It remains to be seen whether China will have the range of stores that offer price differentiation on a national basis. Major distribution chains are not yet available in China on a widespread basis, and mass marketing of products in chain stores is still in the early stages.

Advertising is relatively new to China. The propaganda posters of the 1960s, 1970s, and 1980s finally gave way to advertising billboards and posters for items ranging from candy, cigarettes, and toothpaste to watches. The advertisements for these products largely mimicked the Western imagery for advertising: an attractive woman holding up a product. Advertising today in China still mimics Western communications, only now the attractive woman is not holding the product; she is instead shown experiencing an emotion related to the product, and these new subtleties are accepted in China as they are in the West.

Access to vast numbers of products is also relatively new in China. Where the average consumer in the 1960s and 1970s in China might have had a choice of four hot water thermoses for their tea and very few electronic items, the West had numerous choices for electric shavers, refrigerators, radios, and an abundant number of household accessories and fashions. Choosing among many types of brands, buying items for self-expression, and evaluating product quality and details more closely are some of the newer activities around purchasing in China. But just because these are new activities for the majority of the older generations and the younger ones with more buying power does not mean these newcomers are not savvy. In fact, they are adept at comparison shopping, comparing notes with family and friends on various products, checking Web sites for variety and pricing, and experimenting with lower-priced items before deciding what they like. Today's younger generations in China are very conscious of brands and styles, especially in cities such as Beijing, Shanghai, and Shenzhen, where the pressure to be sophisticated is higher. Those who are more affluent are likely to feel peer pressure to have the latest brands. Their sophisticated cousins in Hong Kong have long been exposed to brands for just about everything: fashion, makeup, furniture, automobiles, foods, and services. In Hong Kong, having brand name products is a way to express one's status.

Young girls in China's second- and third-tier cities choose clothes that are similar to those their counterparts in the United States wear. They are slowly gaining confidence in choosing what to wear to express themselves, and it often comes as an eclectic everyday mix of clothing with Western influence (figure 5.1).

Young people in China today are brand conscious but not necessarily brand loyal. Brand loyalty was built over years in the West through

Figure 5.1
Everyday clothes for Chinese women in second-tier cities. (Courtesy of PolyU Asian Lifestyle Lab.)

extensive advertising directed at influencing customers' beliefs about a brand. Most Western products have not been available in China long enough to develop brand loyalty, except for major brands such as Kentucky Fried Chicken, McDonald's, and Coca Cola. Top European luxury brands are now available in all the first-, second-, and third-tier cities in China. International brands like Google, Microsoft, Nestlé, Ikea, and Walmart have found their way into the everyday fabric of Chinese brand offerings.

Nonconsumable Western goods have a long way to go to secure brand loyalty in China. Although Coach and Louis Vuitton bags may sell well, these companies cannot expect repeat sales over many years. China is on its way to developing its own brands and may prove to be highly competitive in coming years, especially if there is cultural pressure to "buy China."

Chinese brands still have to work harder at generating brand loyalty due to the short amount of time these products have been available on the Chinese market. Directed advertising focusing on Chinese customer loyalty is not yet widespread. This concept may take hold in the future, but it will need to be presented over several years and in a way that grooms Chinese customers for loyalty.

Chinese brand loyalty for Chinese products will need special advertising because of counterfeit products. The Chinese public is distrustful of some of their own food brands due to issues with tainted baby formula, pet food, and other food. Building a trustworthy food brand, with long-term customer loyalty within China, will have to focus on trust, especially for food.

Every province in China has its own purchasing patterns due to the differences in the culture in each region, the percentage of rural households, and types of distribution outlets available. Some provinces may not have certain Western products available because of patterns of distribution. Fashions available in some provinces such as Yunnan may seem ethnically oriented compared to what might be seen in Beijing or Shanghai.

The New Classes

Social classes, which are defined in the West by family income, occupational status, and educational attainment, have not been as clearly differentiated in China, writes Pierre Xiao Lu, author of *Elite China*.[1] China's super-rich or upper-upper class are made of small numbers of well-established families who belong to country clubs and sponsor social events, serve as trustees for

universities and hospitals, and may be heads of firms or prominent professionals in law or medicine.

The newly wealthy in the lower-upper classes are successful business executives who show their new financial status through buying luxury items. They have not yet been accepted into the top of society.

The upper-middle class is made up of upper management in companies or local government and small business owners who have done well financially. They are high-achieving professionals and entrepreneurs who are family and career oriented. Their concerns are good housing and education with the occasional purchase of a luxury or status item, such as an expensive car. In the lower-middle class are nonmanagerial white-collar workers and highly paid blue-collar workers who want to avoid fads and want to be seen as having respectability. Their purchases tend toward a small apartment, an occasional trip to Hong Kong with a group, or special items for their child such as a computer or phone.

Lifestyles of Wealthy Chinese

Sunny Wong, of Li & Fung's designer menswear subsidiary Trinity, explains the rapid changes in classes in China: "Rich mainland shoppers are becoming obsessed with designer clothes as they seek to become more sophisticated."[2] He knows this comes as a surprise to fashion-savvy Hong Kong residents because they remember mainlanders shopping "with price tags still dangling off their designer sunglasses." He also finds that the men in China come into his shop in twos and threes and spend a lot of time asking questions. "It is an education they want," he comments.

The newly rich in China are becoming more discrete in light of the recent spate of corruption trials and ill feelings toward people who have made a lot of money. Some prefer to be low-key in their purchases, requesting items with smaller logos or having logos removed from clothing so as not draw to unwanted attention yet still have the luxury of expensive clothing.[3]

Most of the newly wealthy Chinese are under forty-five years old. Historically there were no wealthy people before 1978 because everything was owned by the state and private wealth accumulation was difficult. Not shy about stating the facts, David Zhong is chief executive of the Shanghai Millionaire Fair, an annual event for the wealthy that offers a chance to learn

about luxury items and fashion.[4] His suit is Armani, his shoes Cole Haan, and his shirt by Dolce & Gabbana. He said of his purchases: "I may not be the richest person in China but I am typical of the 'new rich' who our fair caters to. It has a negative connotation but it's accurate. We got rich only in the last ten to fifteen years, and we should learn to enjoy life in a stylish and respectable way."

Some of the newly wealthy Chinese people care deeply about preserving China's traditional culture. In Xian, Yang Shuanglin is restoring an eighty-six-room estate called Gao Fu that was built four hundred years ago during the Ming dynasty (1368–1644).[5] He does not want to turn it into a commercial venture such as a restaurant or hotel because "commercialization has destroyed too many historic buildings and I want to protect this treasure as it was. It's running at a loss but that's fine with me." Other wealthy mainland patrons are collecting art to preserve the past and as investment. Traditional Chinese landscape and village life paintings are revered art forms in China. Ink paintings with calligraphy done by masters such as Fu, Zhang Daqian, and Qi Baishi are in demand by wealthy investors.

Westerners have been the main purchasers of Chinese art and antiques in the top auction houses in Hong Kong. Now this role has switched to mainlanders; they might not have much knowledge about art so they are looking to invest in well-known pieces, such as furniture used in imperial households. Noting these changes, Andy Hei, founder and director of the Hong Kong International Art and Antiques Fair, said that 80 percent of his clients in the past were Americans: "Now 95 percent of my clients are Mainland Chinese. . . . I can't even find the words to describe how rich they are. . . . You just can't imagine the amount of money they spend."[6] Sotheby's international head of Chinese ceramics and works of art, Nicolas Chow, said: "In the past five years the number of mainland clients had increased at least threefold and prices had tripled or quadrupled."[7]

Many of the newly wealthy in China are enjoying their fortunes in different ways. Wang Zhongjun, half of the famous Huayi Brothers Media Group, at age forty-eight finds their company to be one of the top film companies in China. Huayi Brothers; sales in 2004 were 35 percent of the total sales in the film industry. His lifestyle now includes playing cards with friends and being "obsessed with imported BMW cars. Wang Zhongjun enjoys the mogul lifestyle, with an impressive collection of paintings and a stable of 60 horses."[8] Exotic and expensive cars can be seen parked at the

best restaurants and hotels in the top cities in China, with drivers waiting in them. Rolls-Royce and Bentley car designers used to anticipate the desires of their Western customers, who were largely bankers or families with old money. But now their focus is on the Chinese wealthy, including the "offspring of Chinese coal-mine owners."[9] Ms. Wong, in Beijing reports: "The rising power of the cashed-up Chinese means they have more say in how they look and drive on the road." In 2010, 404 Bentleys were sold in China and 422 in 2008. Bentley has created a "Design Series China" with the colors blue, khaki, and brown. For all other markets in the world, the automobile is available in only a single color. Other luxury car companies are altering designs for the Chinese market by, for example, shortening the length. Rolls-Royce dealers in China, believe that mainlanders do not like longer cars because they feel they are "less elegant."[10]

More than expensive autos have captured the attention of the wealthy in China. The desire to try new food and drink is there as well. Wine has become a passion for many mainlanders who want to drink more and learn more about fine dining. ASC distributors, a Shanghai-based company, has seen a sharp rise in sales over the past decade as the Chinese have developed an interest in wine. Many patrons have experienced wine in other countries as they travel or study in cultures famous for wine. St. Pierre, the managing partner for ASC, said, "Courses are proving popular because of the mainland Chinese desire to learn more about how to enjoy their life in a sophisticated way. . . . Many have the money now, but because information regarding wine is limited there is a built-up demand. The same can be said for fashion and food. They are most interested in learning the fundamentals . . . what wine goes with what food."[11]

Jason Shi, a sommelier based in Beijing, believes that "wine is still considered a form of luxury here in China. As more and more people grow in affluence, they naturally want to experience luxury on different levels, whether it is driving a luxury sports car, wearing the finest clothes, or drinking the best wines in the world."[12]

In Dongguan, in the south of China, a restaurant owner watches a couple drive their new Porsche into town after having a "gourmet dinner . . . where they dined on Angus steaks, toasted each other with red wine, while he smoked cigars." They are investors, he said; "their business prospered so much that they recently changed their car to a new Porsche from an S-Class Mercedes Benz limousine."[13]

Travel for the luxury class is not only about expensive cars and fine din-
ing. Luxury hotels are being built throughout China, many of them old
and reputable brands. The Four Seasons, a luxury Canadian-based hotel
chain, "may probably have as many hotels in China as in North America,"
says Isadore Sharp, chairman and founder of the hotels.[14] China may de-
velop a car culture complete with holiday road trips enjoyed as they are in
the United States and Europe.

The wealthy, along with others in China, have to deal with day-to-day
uncertainty. With their fast-changing world, the newly wealthy are vigi-
lant about keeping their hard-earned place in society and what they have
accumulated. From the posh residential penthouse of Shimao Olive Gar-
den, a housing development, the Olympic stadium, Water Cube (the na-
tional aquatics center), and the skyline of Beijing are visible. For wealthy
tenants of this development, there is a major problem: Government of-
ficials have allowed a road and bridge to come within 10 meters of their
homes, which will soon be gridlocked with traffic. Peter Simpson reported
that "overnight the Olive Garden residents, who are lawyers, factory own-
ers, bankers and financial investors, have become brazen property rights
activists."[15]

In the future, China will most likely see the new wealth coming from
the manufacturing sector. As the Chinese government looks for new ways
to develop high-end brands, there will be major support for those that that
"favor higher value-added industries such as sophisticated electronics and
heavy machinery, possibly at the expense of low-cost manufacturing and
assembly.[16] The government and private investors will help some of the
lower-end Chinese manufacturers move from multinational clients with
small jobs to developing their own designs and brands.

Wenzhou, originally one of the poorest cities in China, has catapulted to
great wealth by relying on its own residents. The residents began by trading
small products such as tea and leather products. In 1978 Wenzhou became
one of China's first private economies. Zhou Dewen, the SME Development
Promotion Federation chairman, said "he was astonished when at a busi-
ness dinner last month 15 entrepreneurs emptied 16 bottles of Chateau
Lafite Rothschild."[17]

The wealthy in China can now afford the fines imposed for having
more than one child, and those who do not have a son will consider that

option, flouting the family planning rules that were implemented in the late 1970s.[18] But most couples in China cannot afford another child given the rising costs of housing, private education, and the cost of good food. Upscale families search out international brands of foods for their children, citing the mistrust of food in China.

The newly wealthy in China became rich mostly from mining, real estate, and property development, or from early start-ups in areas such as Internet software products or manufacturing. Many became wealthier from their investments and purchased property. Many Chinese also are looking for homes abroad, with values of $300,000 to $500,000, as investments, with the United States and Australia being the top markets now.[19] They hope to take advantage of the slumped housing market in the United States and are looking for communities with good schools and amenities such as parks and retail outlets to enhance their investment.[20] The middle classes are spending their money on housing closer to home and private schools for their child.

The Middle Class

The definition of *middle class* in China varies from source to source. The Chinese Academy of Social Sciences says the middle class "accounts for 20 percent of the nation's population," while state media sources say the middle class in China accounts for 11.5 percent of the population."[21] The middle class is made up of the teachers, scientists, white-collar managers, and well-paid blue-collar workers. They also like to show their status with the occasional luxury item, but their focus is on educating their child and comfortable, reasonably priced housing.

High-end housing developments can be found in every first-, second-, and third-tier city in China. Gated housing compounds with swimming pools, a clubhouse, tennis courts, and guards are common. But for the average person in China, these living environments are out of reach, and lower-cost housing means a long commute to work. Although Luo Yanchang, an office clerk in Shenzhen, has a job that keeps him out of the lower economic class, he has decided to stay in what some might call a slum. The housing offered to him through the government, he says, is too far away from work, and the transportation costs are too high. Fiona Tam, a reporter

for the *South China Morning Post*, wrote that "local governments generated 1.5 trillion yuan from land sales [in 2009], nearly 5 percent of China's gross domestic product."[22] This money generated from land sales is a point of contention with the middle and lower classes in China who do not benefit from these sales and believe their homes, businesses, or farms were taken in the name of progress for someone else.

New wealth has encouraged people to spend. For some, saving for old age has taken a back seat, especially since the national government is promising health care assistance. Xu Zhanrong, a car dealership deputy general manager, says of his customers: "Now they find they have more money to spend and enjoy life more, however they want to use it. . . . From what I see, people are changing very dramatically."[23] Evidence of this new purchasing power is his difficulty in keeping in stock Wulings, a minivan brand that is a joint venture between General Motors and Liuzhou Wuling Motors and Shanghai Automotive Industry.[24] "Enjoy life and enjoy wealth" seems to be the mantra of the middle and upper classes, while the lower classes are struggling to find education, medical care, and housing within their price range.

The Lower Class

One of China's biggest problems today is the wealth gap. Hundreds of millions of people have been raised from the lower-income classes through education, migration, or entrepreneurship. But Andrew Batson, a writer for the *Wall Street Journal,* cautions that "the incomes of the people at the top have risen much faster than the rest, creating new divisions in a once-egalitarian society. Tensions between property developers and dispossessed farmers, factory workers and their rural work force are often a flashpoint for social conflict."[25]

Even traditional forms of transportation are being affected by the affluence in China, and the push to make way for cars is evident in every city. Bicycles are seen less and less, and even the electric bike is threatened with extinction. The larger of the battery-operated bicycles, the electric bike is often used for hauling small loads at small distances and is inexpensive to buy and maintain. It is the common means of transportation in rural areas and major cities alike. However, the Standardization Administration of China is now suggesting that riders of these bikes need licenses, but the

owners say they cannot afford them. The possibility that licenses will be required is hurting the manufacturers of these bikes and the workers who use them.[26]

This class, however, has heroes to look up to. One of them is Wang Shi, who went from being a migrant worker to the top of the housing industry in China. His company, Vanke, has seen a decade of profits, reaching revenues of $5 billion in U.S. dollars. Wang Shi now builds affordable housing for the middle class. An individualist at heart, he found his military service difficult because of the authority, but he said it taught him the ability to "endure hardship, what the Chinese call *chi ki*, 'eating bitterness.'"[27]

Brand Development

China is made up of five provinces and has a population of over 1.2 billion. Local economies and cultural habits differ greatly from province to province, but migration has had an effect on purchasing habits. Online surfing to study products, in-store examination of products, and word-of-mouth are the prepurchasing activities of most people on the mainland.

The demand for certain products and brands has remained strong throughout China over the past five years. The first category of products in demand is luxury brands. The demand for high-end goods is coming from the wealthy in China and the rising classes who spend much of their income on these items as they represent status. The second area of demand is for high-tech products. Mobile phones, televisions, and any of the latest communication and work equipment are strong in sales but only for certain brands. The wish to be seen with the latest gadget also drives technology purchases.

Fashion and fashion accessories are also in demand. Fashion purchases are used to communicate status and sophistication. Beauty products are in demand as well because Chinese businesswomen and fashionable wives want to appear as attractive as possible.

The demand for high-end transportation has not slowed, and the demand for midrange-priced autos has increased as well. Very expensive imported cars and motorcycles are seen in every first-tier city in China. Now that China has approximately forty car companies, the future trend may be to purchase high-end Chinese along with Chinese-designed high-end fashion. It also be that these products will become attractive exports to a Western world always looking for something new.

Where the Money Goes

Internet savvy users welcome online shopping opportunities. They like the convenience and privacy of online shopping and the ease in comparing products and prices. Anyone who has navigated traffic in China or tried to span a large city will agree that online shopping will grow steadily in every province because travel in cities is time-consuming. Also, pickup and delivery services suit cities where auto ownership is low. Since buying online is becoming easier with special prepaid cards (not credit cards), a purchase can be made online or paid on delivery.

China issued its first credit cards in 1985. In 2003, there were 3 million credit cards issued. By 2007 there were 99.76 million issued.[28] Although credit card use has increased in China, it is still not as prevalent as in the West, largely due to the Chinese banks' unwillingness to allow indiscriminate borrowing. However, if foreign banks are allowed into China to offer credit cards to the general populace, it could stimulate the Chinese economy, but it could also contribute to a "false" economy.

Top Western Brands

From Adobe Software to Oreo cookies by Kraft, American brands are making inroads. Hotels such as Hilton, Sheraton, Radisson, Hyatt, and Marriott are in the top cities. Buick, Cadillac, and GM cars have a presence. Apple, Microsoft, Adobe, Sun, and American Abbot Labs are selling their technology and science. Brands such as Starbucks, Nike, Kodak, Gillette, Kleenex, Ritz, Coca Cola, Pepsi, and Hershey have all made it to the shelves of stores in first- and second-tier cities.[29]

Kentucky Fried Chicken (KFC) was one of the first fast food restaurants to open in China in 1987. Early on, KFC took on Chinese characteristics by offering some Chinese food choices. McDonald's opened in China in 1990. Yum! Brands helped to create a Western market for fast foods through KFC and Pizza Hut but realized that Chinese people would not eat Western food more than two days a week. Thus, they started East Dawning, a chain of Chinese fast food restaurants, and Little Sheep Hot Pot for a casual and local restaurant experience.[30]

All high-end shopping districts in the first- and second-tier cities sell the same brands in as in Europe, the United States, and other developed parts of Asia: Gucci, Prada, Burberry, Zegna, Hermes, and Rolex. Mercedes,

Audi, Volkswagen, Toyota, Porsche, Fiat, and Rolls-Royce are available as well.

According to the *Observer*, leading fashion brands are opening more stores in China. Vivienne Westwood will open twenty boutiques, and Burberry will add sixty-six stores to its current forty-four. Coach, the American business, will open twenty outlets, and Ferragamo plans ten. Levis will soon reach one thousand outlets, and Dior will launch items made especially for the Chinese market.[31] The author of the piece in the *Observer* offered: "What's distinctive about style in China, however, is that it incorporates all of these looks and integrates them in a way that is quintessentially Chinese. This comes as no surprise to those familiar with China's history. For thousands of years, the country has excelled at integrating the features of other cultures into the traditional Chinese way of life and using those outside influences to refine or revive its core culture."[32]

Top Chinese Brands

Li Ning, the sports shoe company, is on the rise. Its CEO is a star athlete and knows how to sell shoes. Li Ning is now sponsoring some of the top athletic events internationally. Once criticized for having a similar logo and saying as Nike, it is adjusting its brand with a different "swoosh" and a new motivational saying.[33] It is seeking to take on American and other markets to become a global brand.

Cherry Automobile has teamed up with Chrysler to produce cars for China and for export. Cherry also teamed up with Fiat in Italy and has moved into the Uruguay and Argentina markets as well. Meanwhile, Chinese autos are in demand in Russia because of their price. Cherry is planning to build a global brand through its partners. Japan's Datsun, and Korea's Hyundi were first derided for quality, but the Japanese and Koreans set their sights on making better cars, and those brands are now acceptable to the Chinese people.[34]

Haier, the white goods manufacturer, and Lenovo, the computer company, are well-known international brands. Both started out as state-owned enterprises (SOEs) and have since become private. Many of the large Chinese SOEs are unknown to the rest of the world, but China plans to help many of its companies become global brands.

Although it was started decades ago from a German brewing process, Tsingtao Beer is an internationally known and respected Chinese brand.

New versions of food and drink are being created and branded as well, with the hope of becoming a major brand over the years. China has natural products in medicine and food that could be developed for export. Many of these opportunities are yet to be explored.

Regional Differences

Xian, once considered a backward city compared to the trendy east coast cities, has stayed strong throughout the financial crises that have gripped other Chinese cities. This is because Xian has a solid market that sells to Chinese consumers and is not totally dependent on exports from the region. It is true that the national government invested in Xian's infrastructure and gave it financial assistance when certain brands were purchased, but the economy has remained steady. Xian is an example of how "the domestic market will be the leading reason for China's future development," says Chen Baogen, Xian's mayor. "Xian is different from the coastal cities."[35] The regional areas of China, backed by strong, well-run provincial governments, can make the difference in having a strong internal market.

Made in China, Designed in China

When He Renke, dean of design at Hunan University, visited Europe, he wanted to buy something for his son that was made in Europe because it would be a unique gift. But it seemed that everything he looked at was made in China. He eventually bought headphones that he thought his son might like and but did not see the "Made in China" impression in the dark plastic. Back in China, however, his son found the origin: "Made in China."[36]

The opportunities for design in China are endless. New markets, new products, new emerging class differentiation, new housing, and new ideas are everywhere.

From an analysis of the current Chinese culture, there will be three impacts on design.

Western with Chinese Characteristics

In the short term, Chinese consumers seem to prefer Western items for showing their status, but they prefer local and inexpensive items that no one else will see. They also want a bargain on the local Chinese products and expect them to be cheap. Higher prices for local Chinese goods will

not be readily accepted for now. The only Chinese products that the people seem to value are antiques, art, and expertly prepared Chinese wines and dishes.

Meanwhile, Western companies are adjusting their products for the Chinese market. From shorter luxury autos, to the reformulated Oreo cookie for China, Western brands are considering ways to sell to the Chinese market. Companies such as IKEA and Steelcase are studying Chinese markets to adjust their products to be a better fit for the size and shape of homes and offices in China. The longer a Western brand can stay in China, the better the possibility will be for word-of-mouth marketing opportunities, which remains a strong aspect of marketing on the mainland.

Pop Culture Designs

Since the general population of China is still sorting out its likes and dislikes in terms of products, sports, and entertainment, products and stars will come and go quickly. One reason for this is that China is being affected by Asia as well as the West. Korean pop stars and Japanese *manga*, or cartoons, were popular in China for a few years, but China Chinese pop stars and its own form of anime are emerging. Films produced in China are still subject to government censoring, and there will not be major changes in content in the near future that are not aligned with the Chinese government values for appropriate content.

Superficiality to Super Fiscal

Items that are truly an embodiment of the Chinese culture and that are well designed will become significantly more valuable. We have seen products that reflect both eastern and western cultures, and the appearance is unimpressive. However, designs that can transcend the superficial Chinese visual icons to convey a deeper sense of meaning will be of value. Chinese designers should focus their work on the expression of their culture with quality craftsmanship and materials. These pieces will rise in quality in the short term. Collectors' items will become a passion in China as the economy improves.

In 2009, the Chinese government began a 4 trillion yuan stimulation package to stir consumer spending. This stimulus, in addition to education and health care assistance in rural regions, is expected to increase consumer confidence. Spending, not saving, has been the recent pattern in China, now summed up in the phrase, "Enjoy life, enjoy spending."

6 Third-Generation Designers

Today the title "Chinese designer" spans a range from the first graduates of new Chinese design programs to seasoned professionals with international experience. They work in large private corporations or state-owned enterprises, design consulting firms, for manufacturers, or as independent entrepreneurs. They work in the areas of advertising, animation, branding, graphics, environment, industrial design, information design, interior design, product design, service design, and visual communication, with the boundaries even more blurred than in other parts of the world. The design discipline distinctions are just coming of age in China in large companies and especially in small- to medium-size enterprises that realize they may need a product designer and a graphic designer.

Major Chinese corporations such as Haier, Lenovo, and Li Ning work with Chinese designers and foreign design consultants as they push their brands to global distinction. International design consultancies such as Continuum, frogdesign, ideo, and Nova hire both designers educated on the Chinese mainland and overseas. International firms such as Coca Cola, Google, Microsoft, and Steelcase look for Chinese designers to help them understand the local culture. But it has not been easy for Chinese-educated designers or their professors.

Listening to Chinese design educators gives a sense of where China is headed in relation to creativity and innovation and how far it has come. These insights help to illuminate a small portion of design education history and what a few key professors believe is the way forward to their dream of "designed in China."

Several of the educators profiled here studied or worked in the West, and that background helped to shape their experience and confidence. They are forging a new path for China to engage in design education. Many of these

design educators believe that their Chinese design students are making the shift from determining just the shape of a product to true innovation and marking the distinction between art and design at the same time.

Early Design Educators

Huang Yu Yu

Huang Yu Yu, one of the first female professors in industrial design in China, worked at the Beihang University of Aeronautics and Astronautics and was instrumental in bringing ideas from West to the East.[1] She says of those early times in China:

> When the universities in Beijing closed, we were free to travel anywhere in China. It was an exciting time because we were part of a revolution of change. I served as a Red Guard for a brief time before beginning work in a factory making airplanes. There was no industrial design profession back then. The professors taught drawing, art, or engineering. Two professors from Tsinghua University had learned of the Bauhaus from their time spent in Japan and Germany, and this influenced the work at Tsinghua.
>
> When the universities opened again, I was picked to go to the United States to study. I was amazed at the number of companies and products. During my studies, I met Roland Johnson , a manager at Procter and Gamble, and worked for him for a few years. When I returned to China, I began to teach design. Industrial design as a profession was still not that accepted in the universities, and they were still teaching in a very technical way in some universities. In other universities, they were teaching design in a very artistic way.
>
> When China has a new generation of industries, the schools will begin to change to the need for a balanced industrial design education. There are too many artistic industrial designers. The students need to get an innovative spirit. Beijing alone spends 500 million yuan a year on creative industries and there are 300 arts-based schools and 200 engineering-based schools. Design is for industry, not for art.

She held the first Industrial Design Education Conference in Beijing in 2001, in conjunction with me and with cooperation from the China Industrial Design Society and the Industrial Design Society of America.

Cai Jun

Cai Jun, a professor at Tsinghua University and former chair of the design program, has been an industrial designer and educator since the 1980s and therefore is one of the earliest practitioners in the field.[2] As a result of his leadership as professor and then head of the Department of Industrial Design from 2006 to 2009, Tsinghua University's industrial design program

has become the top such program in China. He also helped to establish the Beijing Industrial Design Center in the 1990s and was an early consultant to Lenovo. Cai worked in the countryside during the Cultural Revolution when the schools were closed. Some design professors were asked back to teach after the Cultural Revolution. He remembers that in 1974, much design activity was directed toward government projects such as the People's Great Hall. In addition, many new designers turned to interior design, furniture, and lighting, the start of what was then called the industrial arts. The Red Flag car was also important as it was the one Chairman Mao used for state events and visits. New work on automobiles in China was started again in 1974.

Cai believes that design in China must now connect with industry more and help designers focus on global marketing through user research. He, like Huang, believes that there is still a confusion of design with art in China and that processes like user participation will lead to good design.

Lui Zhen Sheng

Lui Zhen Sheng, director of the Industrial Design Department Academy of Arts and Design at Tsinghua University, is passionate about design education.[3] He remembers that in the early 1960s, the Academy of Arts and Design was focused on ceramics and products, and the Central Academy of Fine Arts was focused on painting and what was called revolutionary art, where the artists were directed by their government to produce paintings and murals depicting the ideals of the revolution. When the schools closed during the Cultural Revolution, many professors went to the countryside to work in factories, an experience that instilled sympathy in them for the people, he said.

He notes that "the products made during these years were electric fans, TVs, refrigerators, and cars." Many Chinese companies stopped their own design work to help other foreign companies manufacture their products. Several joint ventures did not go well, and several Chinese brands were discontinued because competing projects were not allowed in the agreements. Many Chinese manufacturers forgot how to be innovative because they were doing work for companies that just wanted manufacturing.

In the early days, there was no advertising or marketing. Then in the 1980s came a corporate identity movement to brand Chinese companies, and graphic design was needed for corporate identity, packaging, and company manuals. Now, he says, marketing, consumer research, and branding need to be employed to sell products.

Xin Xiangyang

Xin, born in 1971 in a small village in central China, was educated as an engineer and designer and also trained as an artist.[4] His life changed when a visiting American teacher to his town admired his artwork and became his mentor. He went to study in the United States, first at West Virginia University for Art and then at Carnegie Mellon University, where he received a Ph.D. in design. After working in Hong Kong, as the director of a top master's program in interaction design and user experience, he became Dean of the School of Design at Jiangnan University in Wuxi.

While he is understandably proud of China, he also believes that "the Chinese education system is not yet where it needs to be." Although intellectual property was recognized in China in 1984, it has not always been understood or protected. He believes that intellectual property needs to be protected and paid for, that venture capital is where the first "bucket of gold" must come from, and that the banking systems need to put processes and resources in place to help small companies with a product and vision realize their ambitions.

Xin notes that hundreds of projects stopped in China during the opening-up period and agrees with what others have said about this period and its effect on innovation. Many Chinese companies stopped what they were working and turned to manufacturing parts for foreign companies. Xin himself was working as an assistant engineer for General Motors when he noticed other companies could not continue their own work on products or take on competitors' products. He mentioned that Boeing approached a Chinese airplane manufacturer at the time. This company realized that it could make more money manufacturing airline doors than working on its own products, and it turned exclusively to that work.

He believes that China now needs what he calls "conscious consumers"—people who understand what is behind the making of those products in relation to chemicals used, manufacturing processes, and labor issues. He also believes that many rural consumers are not experienced or informed consumers and need to be protected when making large purchases by making information available to them such as product maintenance or safety issues. He is looking forward to the time when Chinese-driven products and culturally based innovations are common.

He Renke

He Renke, a dean at Hunan University, believes the future of design in China will be more diverse, more green, more open, more confident, and more global and that when this happens, the rest of the world will recognize China's design renaissance.

He Renke has been a major force in China for design education for many years.[5] He received his design degree in the United States at the University of North Carolina and remains up-to-date on U.S. design practices. He has worked to build quality, strength, and confidence in the student design work that he oversees. This eventually led to the beginning of the Chinese LotusPrize, a prestigious Chinese design competition, which Renke started with a team, and the prize is supported by the local government of Hunan. A LotusPrize exhibition is seen in figure 6.1.

Chinese Corporate Design

Yao Yingjia

Yao Yingjia, a vice president and director of the Innovation Center at Lenovo in Beijing believes that great business leaders know the value of design.[6] "Liu, the founder of Lenovo," he says, "learned very fast and was

Figure 6.1
LotusPrize 2010 exhibition. The LotusPrize has several categories of product design that range from housewares to emergency vehicles.

a genius at understanding design in the early stages of the company. Our current leader, Yang Yuan Qing, also understands design, branding, and business. He understands design is a bridge to connect the different parts of the organization to transfer technology products to the marketplace."

Yao explains his design philosophy in this way: "Design is how to solve the problem in a new way. It is also about how you can learn from everyone. A safe learning team is one where they don't always need a manager to direct them, but they learn on their own through each other. When they feel safe, they will ask more questions and try new things. My advice for young designers is about attitude and lifestyle: work hard, learn every day, work long hours, stay curious, and take care of people. The hardest thing to keep up with when you get older is to keep a curious attitude. It is important to keep your curiosity at a high level."

His suggestion to companies that are struggling is to look at design as more than a tool: it is, he says, the basis of a company's brand. Design thinking and design marketing become resources for solving problems. You can use designers to view things and to think about problems differently.

He believes the greatest general designer in China was Deng Xiaoping for several reasons: he thought about products, people, organizations, industry, and society; he saw the importance of innovation and planned well; and he helped the government develop an awareness of the importance of design. As a result of Deng's planning in the 1980s, design began to appear in China in many areas in the 1990s. Educational institutions opened new design programs, manufacturers began to experiment with new products, and designers began to open their own companies.

Award-Winning Chinese Designers

I chose the designers featured in this section because of their excellent design work in addition to their business skills. Unlike many Western design firms that specialize in only product or graphic design, Chinese firms such as Neri & Hu in Shanghai and LKK Design in Beijing produce a range of designs. Guo Pei and Ma Ke, famous fashion designers, represent the extremes in fashion design that exist in China today, from Guo Pei's ornate and royal gowns to Ma Ke's natural and earthy clothing. And He Jian Ping's graphic posters are an eclectic visual surprise, always well executed and of superior quality.

The various regions of China produce significantly different designs. Chinese design in the major eastern cities such as Beijing, Shanghai, and Hong Kong show a high level of sophistication and are geared to a luxury market. In western areas of China such as Yunnan, the graphics show a rich ethnic minority influence in the use of many colors and in form and texture. The Tibetan (west) and Mongol (north) regions show local influences in design through the shape and color of graphic treatments. Examples of these striking regional differences can be seen in the work of two award-winning, world-famous fashion designers, Guo Pei from Beijing and Ma Ke from Zuhai in southern China. These regional differences may fade as China modernizes and its education system becomes more national. Moreover, as people more frequently move around in China, there may be a diminishing of the effect of localization on design, but this can be decades off as local customs and colors are still strong in many regions such as the minority villages in the Yunnan province in the Southwest of China.

Fashion Designers

Guo Pei's fashion designs remind us of the intricate imperial beauty and luxury of ancient Chinese courts (figures 6.2, 6.3, and 6.4). Dramatic, structured, and detailed with stunning beads, fabrics, and headpieces, her designs provide "something arty and very far removed from reality."[7]

Ma Ke's earthy designs are in stark contrast to those of Guo Pei. They remind us of the Chinese closeness to the land and the sometimes harsh existence of those living in rural areas (figures 6.5 and 6.6). Her designs, she says, aim to distinguish clothing from fashion. Chinese craftsmanship and culture figure deeply in her desire to design clothing that is also ecological and ethical, whereby natural materials and fair labor practices are used. In Ma Ke's acceptance speech as the World's Outstanding Chinese Designer of 2009 at the Business of Design Week in Hong Kong, she said she has "come to understand that design is not a means for self-realization, nor should it be a vehicle to achieve wealth and fame. The true meaning of design is to create a perpetual state of harmonious existence between mankind and everything that inhabits the world."[8]

Neri & Hu

Award-winning product and interior designs have come from Neri & Hu Design and Research Office, a design team based in Shanghai that was

Figure 6.2
Surreal imperial beauty. (Courtesy of the Hong Kong Trade Development Council)

Figure 6.3
Culture mix. (Courtesy of Hong Kong Trade Development Council.)

Figure 6.4
China blue and white influence. (Courtesy of Hong Kong Trade Development
Council.)

Figure 6.5
Nature's influence. (Courtesy of Ma Ke.)

Figure 6.6
Natural line up. (Courtesy of Ma Ke.)

founded in 2004. Lyndon Neri and Rossana Hu design award-winning life-style products, such as seating and ceramics, interiors for restaurants and homes, and a magazine, *manifesto*. This magazine has helped Neri & Hu position itself as the arbiter of lifestyle products in China. The firm's Zisha Tea Project, special teapots and teacups made from a local clay, shows a unique sensitivity to color and form. The subtle changes in size, shape, and color of the teacups they design draw the eye in for closer inspection (figure 6.7). Zisha, a rare clay, also known as purple sand, was discovered in Jiangsu province about 500 years ago; it is known for its capacity to retain heat, prevent oxidation, and preserve the flavor of tea. And over time, the teapot and tea cups become seasoned by the drink they contained.

The mirrors shown resting against the wall in figure 6.8 are reminiscent of bamboo ladder shapes common in Chinese rural households. The mirrors in the figure are made from black walnut wood, which provides strength and has a striking wood grain.

The interior design work of Neri & Hu is not as visually quiet as the products the firm has designed. The interior for the restaurant called Bei

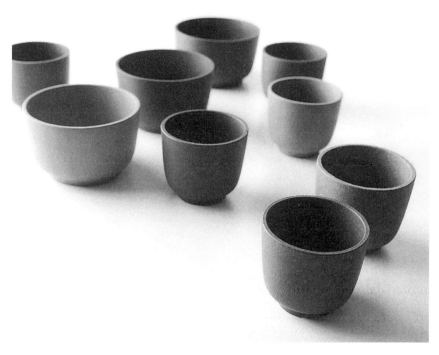

Figure 6.7
Neri & Hu Zisha tea cups. (Courtesy of Neri & Hu.)

(meaning "north" in Chinese) is inspired by the concept of a forest and a clearing (figure 6.9). The entrance to the restaurant in Beijing features wooden "trees" that screen the "clearing," that is, the dining area of the restaurant. Lights dance above like stars, and the low ambient lighting contributes a sense of calm. The interior of the room in figure 6.10 reflects Neri & Hu's appreciation for classic Chinese colors of reds and yellows, dark stained wood, and natural materials such as wood and stone, updated and mingling with modern textures and furniture configurations.

He Jian Ping

Born near Hangzhou in 1973, He Jian Ping studied at the Hangzhou Academy of Fine Art and then went on to work in Germany as a professor of design. He now splits his time between China, Germany, and anywhere else his work takes him. His graphic designs for books and other items have won awards, but it is his posters that have become the most impressive body of his work. The posters in figures 6.11 to 6.13 were designed for Asian events.

Figure 6.8
Mirrors as ladders. (Courtesy of Neri & Hu.)

Figure 6.9
Forest interior theme. (Courtesy of Neri & Hu.)

Figure 6.10
Chinese splendor. (Courtesy of Neri & Hu.)

Figure 6.11
He Jian Ping's poster for the seventy-fifth anniversary of the China Academy of Art, Hangzhou, in May 2003. The Chinese character on the poster means "art."

Figure 6.12
He Jian Ping's poster for his solo poster show, Come Back to Asia, the One Academy, Kuala Lumpur, Malaysia. (Photo by Yin Jiang, Beijing, 2006.)

Figure 6.13
"China Image," by He Jian Ping, Berlin, August 2004 . Poster for the Taiwan Poster Design Association. (Photo by Yin Jiang, 2006.)

LKK Design

David Jia, started the design consultancy firm LKK in Beijing in 2004.[9] A multiservice firm, LKK counts among its clients such multinational companies as Nokia, Shell, Samsung, Siemens, Panasonic, and Lenovo. It designs products that range from a subway system ticket machine to a blood pressure monitor with three-dimensional software icons. The company statement notes that its "design is based on research and analysis. Human-centered, sustainable, aesthetical design is our permanent pursuit. We aim to help our clients to optimize the function, value, appearance of products and become more competitive in market." The firm's wayfinding system, or directional signage, shows a simplistic beauty of freestyle Chinese calligraphy and white space (figure 6.14).

LKK has a multidisciplinary team that, it say, seeks to "create happiness." Jia, the general manager of the firm, believes that creativity and innovation are the soul of design, but he also holds that design is strategic

Figure 6.14
Wayfinding signage system incorporating calligraphy. (Courtesy of LKK.)

and must take into consideration clients' and consumers' needs, which usually requires research and analysis of the problem.

Jia identifies confidence in designers as an issue in China today. Clients in China do not always think highly of design, and young designers themselves often lack confidence because they have few models of success.

Jia says, "young designers in China are learning state-of-the-art styles and methodologies from the United States and Germany because most of the products are being made for those markets. These young designers are also looking to Japan for models. Chinese students who travel overseas for their education understand that Chinese culture can be incorporated in their designs, but it is not clear what are China's own designs. There are not enough people to act on this yet, and we need more designers working on Chinese design. There must be an accumulation of work before we can discern and think deeply about Chinese design. We can become mature and then act on this process. Chinese designers also have difficulty seeing a long-term career path. They can be entrepreneurs and good managers too."

Universities that have design programs need to emphasize how to transfer business value to the product or object. Clients understand the difference between art and design, whereas young designers often think design is art. But they should hold on to their dreams, visions, and beliefs, and they must remain passionate about this work.

Digital Media

Animation, game design, and Web site design are alive and well in China. Animation is taught in the major universities, art academies, and animation schools throughout the country. In addition, animation production houses are some of the top employers of the thousands of design graduates every year.

The West has had a long run with superhero animation and products for merchandising. China has the Pleasant Goat, an animated cartoon character in a storyline that has a bad wolf and a smart snail. Pleasant Goat has turned into a merchandising opportunity as well, complete with stuffed animals, goat action figures, and all the other products that children clamor for.

Game designs are being developed solely for the Chinese market. The Chinese government would like games developed in China for China, or the less outside influences from other cultures, the better. Online games of

all kinds, including poker, are currently allowed under the watchful eye of government Internet censors. It is estimated that there are over 100,000 Internet censors in mainland China whose job is to surf the Web for Web sites, blogs, and other software that is considered inappropriate or a security threat. An example of inappropriate sites are those that criticize the PRC government, or its leaders, or incite unrest in some way.[11]

Web sites have been designed for many functions in China, but the largest successes have been with business sites such as Alibaba and Taobao. Alibaba, a major product sourcing site, and Taobao, a selling site, are major online businesses that are becoming internationally known brands. Online business is expected to grow rapidly in China, but it may function differently than in the West since the average consumer in China does not have credit cards.

A New Design Day

Zhu Haoyong, chief representative of INNO Design, recounted that in 2004, everyone was looking for good product and graphic designers.[12] There was a new wave of clients and small- to medium-size enterprises. All the goods, however, were for export markets, not internal markets. Nevertheless, it was a time with many opportunities because designers were able to directly with CEOs. As companies in China grow larger, he believes it will be difficult for designers to spend time with the top people in their design work. And although many of the larger Chinese companies have wanted to work with foreign design firms, which has undermined the confidence of local designers, this is changing.

Confidence in Chinese designers will come, Huang Yu Yu says, when there is a new generation of companies in China. Students will feel confident when their curriculum becomes more encompassing. Although it may seem to the West that China may be five to ten years behind in design, it will not take that long for widespread changes to be implemented. By then, He Renke's Chinese design Renaissance will be underway.

7 Design as the Driver for China's Future Economic Success

In 2004, Premier Hu Jintao's state address spoke to improving the Chinese economy through increased activity in design and innovation.[1] These creative activities will build China's global brands in the near future and provide a base for innovative achievements. Since 2004, first-, second-, and third-tier cities have started innovation parks, art enclaves, design centers, and design programs in universities. Money flows from local governments to a few chosen factories that want to manufacture their own products. These original equipment manufacturers are looking to become original brand manufacturers. But this is not an easy task in a country that is just a single generation past state-owned companies that dominated their own markets.

China wants national brands to drive its internal economy and then branch out to become global. It learned from the West what marketing and branding can do to strengthen regional economies, and it learned from Hong Kong how to manufacture for the rest of the world. This innovation, branding, and manufacturing expertise will position China for its global economy.

Individual Chinese entrepreneurs and partnerships of two or more people are creating private companies at a frenzied rate. Some of the larger private companies are sometimes derived from state-owned enterprises. These enterprises that turn private and the existing enterprises need intensive changes within their company structures in order to compete with companies in the rest of the world.

In the past ten years, Lenovo and Haier, both originally state owned, have become successful global brands. Lenovo made world headlines when it bought the IBM laptop. Haier, one of the world's best-known Chinese white goods manufacturers and a recent partner with General Electric (GE)

in the United States, launched a program of design research to better un-
derstand its local and international target markets.[2] This need for new and
innovative products, plus marketing and branding, seems perfect for de-
signers who want to do design research for target markets, product strategy,
and branding.

Manufacturers in the Pearl River and Yangtze River Deltas

There are approximately 70,000 factories in the Pearl River Delta (PRD), and
as of 2009, approximately 70 percent were owned by Hong Kong tycoons.[3]
These factories employ more than 10 million workers who manufacture
toys, watches, jewelry, shoes, textiles, furniture, paper products, batteries,
TVs, small household electronics, and much more.

The financial tsunami of 2009 and 2010, however, saw more than 10,000
of them on the brink of closing.[4] Many have had financial difficulties as
a result of higher wages, more worker benefits, higher costs for materials
and fuel, and tariffs imposed by the central government for companies that
make lower-grade products that pollute.

When rural Chinese workers relocate from a village or province to work
in a factory, they remain classified as rural workers, meaning they are resi-
dent in a village where their benefits such as eduation and health care are
offered.[5] As a result, their children may not be offered education in the
place where they have relocated. However, manufacturers are considering
moving their factories closer to workers in various provinces, and the Chi-
nese government is looking for solutions to change the status of migrants
so they will be eligible for health and education benefits.

Although these changes in labor laws affect factory profits, they have
meant a better quality of life for the workers, their families, and China
itself. Factory owners are now providing air-conditioning, athletic facili-
ties, better food, entertainment, and sometimes a financial bonus for their
workers. As of this writing, salaries have continued to go up in the PRD and
in the Yangtze River Delta (YRD), possibly signaling the end of cheap labor.

As China's manufacturing costs rise, some clients are considering turn-
ing to Vietnam, India, or Eastern Europe for production. But China's ma-
turing manufacturing infrastructure and Hong Kong's legal and banking
expertise are well respected. In addition, China has achieved an excellence
in manufacturing that will take other countries years to achieve.

Some businesses may look to India for soft goods manufacturing or non-electrical goods production, but not for complex product manufacturing, according to clients who order products in the PRD and the YRD. Many overseas buyers of products manufactured in China are remaining with China for now because they find it difficult to switch to another manufacturer. They are either not aware of others or the lead time to produce a product with a new manufacturer is time consuming and costly due to new product molds, agreements, and so on.[6] The manufacturing system in China is still working well for most international clients, and prices are still acceptable. But as China positions itself to create its own products for its own internal market, it will become less reliant on external product orders.

Some believe the PRD will change drastically over the next ten years and become greatly diversified, possibly focusing on more service products, such as offering financial and legal services. If manufacturers do leave this region, there may be a loss of manufacturing expertise unless these factories relocate farther inland.

New Businesses

The latest statistics from the Chinese government show that the number of e-mail communications is increasing in relation to the number of instant messages. A design manager from Microsoft Research takes this as a sign that the country has an increasingly mature economy because people use e-mail for business purposes. In China, in contrast, instant messaging is for friends. This may be a sign that "pocket companies,"[7] or small one- to two- person companies that can be run with a mobile phone, are moving to become fully fledged companies.

John Woo is a bright, straightforward designer who knows the online business.[8] In discussing online trends in China, he said that online credit card shopping is still small: only 15 to 20 percent of Internet users will try this method, but most default to paying C.O.D. (collect on delivery) or use a cash card that has a specific amount on it that the customer has provided up front. Those who do use credit cards use trustworthy sites such as Alibaba and Taobao. He says that most Internet users are white collar workers, but the future experts in China are still high school students. The major areas of interest for this younger generation are entertainment and trends.

Woo also points out that instant messaging in China is quite high (at 90 percent), whereas e-mail is at approximately 40 percent of users. There is a dramatic difference from the United States, where instant messaging is below 40 percent. But e-mail use is on the rise in China. Where Americans browse content, the Chinese people use it to shop, even though they do not often pay online.

Google did a lot of user testing and user research to understand Chinese Internet users. It needed to know how people want to use the Internet and must prove its findings with data. Google then used these data and user experience metrics for redesigning its site. The company's research shows that Chinese users prefer to open a lot of windows at once and go in one by one because they believe this is an efficient system. They like tabs for organization and multitasking and open a lot of windows for reading, shopping, or gaming.

Woo also believes that education programs teaching user experience research lacks real-world practice. More internships in companies and competitions are needed to bring students up to speed. These design programs need to enable students to design for clients and to nurture them in the ability to make connections between users and clients.

Cathy Huang, founder of China Bridge, a design consulting firm based in Shanghai, has work experience in the East and West and now helps people from both sides of the world.[9] She sees that the young people in China today are interested in personal growth so they will be of value to their company. They want more skills and opportunities to upgrade their jobs, an ongoing trend in business in China that can signify either satisfied employees or regular turnover, depending on what the companies offer.

China's Design Schools

It is difficult to determine the number of design programs in China. In 2007, the Chinese Ministry of Education's official Web site listed 1,125 schools with art and design departments that recruit students.[10] In 2008, the China Industrial Design Society listed 400 industrial design schools in the country. In comparison, the United States had approximately 53 industrial design programs in universities and private institutes.[11] The Chinese Ministry of Education Web site says 2.2 percent of the students in China's

1,900 colleges and universities study design.[12] In fact, China is now the largest market in the world for design education.

Chinese employers and clients, however, say that they do not trust universities' design programs because they are taught by artists or engineers rather than experienced designers. There are not enough design educators to fill the design education positions in the country, and so the focus and the quality of design education can vary greatly. Nevertheless, there are outstanding design education programs in China that serve as models for other aspiring design schools and programs. And although they compete with each other for government resources and ranking, they learn from each other and from foreign design educators who visit or teach in these schools.

Both designers and clients believe there is a confidence issue on both sides that will take some years to correct. But both sides are working together toward a common goal, something that the Chinese are very experienced with given their culture and past. They realize they need each other to move product design and manufacturing to the next level for China.

Working with Western designers is not always feasible for small Chinese firms, and Western ways of working are too foreign for them. Large, well-known companies in China will readily work with, and can afford the fees of, large design consulting firms such as S.Point, IDEO, frogdesign, Nova, INNO, China Bridge, and LKK. This relationship will serve industries well until the design education programs are more mature and China has more home-grown designers of its own. The next phase for design educators is to expand graduate education for master's and doctoral degrees in design. In the not-too-distant future, the more established companies in China will need design managers, design strategists, and human factors experts.

Fundamental Differences in Design and Innovation in East and West

Eric Chan, principle of ECCO Design in the United States and named as one of the world's best Chinese designers by the Hong Kong Design Center, shares his insights from working in the West and comparing it to the East.[13] He believes "the index of creativity is different from culture to culture. Americans place high value on individuality, whereas the Chinese are quiet, prefer harmony, are conforming and nonconfrontational. Westerners take gambles and risks, whereas the Chinese may not have a big idea but

smaller inventions. Westerners sometimes lack patience and make quick judgments. The Chinese have a tradition of following a master whom they respect and want to learn from. They ask, "How can I learn, remember, and give credit?" Through his experience, Chan believes it is best if Westerners take the time to process, analyze, and then make decisions, and it would help if the Chinese were more results oriented and made decisions more quickly.

The East and West work differently in relation to design and innovation because of differences in cultures. Both have qualities from which each other can learn. The well-thought-out smaller and incremental steps that Chinese teams perform allow richer exploration but fewer opportunities for mistakes. The bold, passionate, risk-taking leaps Westerners make as individuals offer a different type of exploration that the East could benefit from. The West appears to move in a more linear way toward a big idea in which details are not as important initially. The East seems to move incrementally toward new ideas after contextual consideration and examination of all possibilities.

Design and Innovation Parks

In order to support its push for design and innovation in China, the provinces have put in place a plan for art, design, and innovation parks throughout the country, with a plan to establish hubs of noncompeting areas of expertise. The innovation parks hope to attract like-minded companies with similar areas of expertise in order to grow an area as a hub. The Tianjin Hightech Park focuses on biotechnology and energy.[14] The Shanghai Park is for high-tech research in Chinese patent development for technology transfer. Several provincial governments are enticing students who are now abroad to come home after graduation or after working in foreign countries.

The Ningbo Innovation Center opened in 1999, early in relation to other innovation parks in China. One year later, the Ningbo Software Park was opened. By 2001 Ningbo opened its Overseas Scholars Innovation Park hoping to lure the best and brightest back to the area. Ningbo, just one hour away from Shanghai, has a well-run science park that has a specific area for returning intellectuals.[15] The Ningbo Software Park focuses on software development for office, intelligence, and network applications. The

provincial government of Ningbo has successfully partnered with local manufacturers and the universities to create a meaningful space for nurturing innovation.

Every day, close to half a million commuters cross the border between Hong Kong and Shenzhen, which are separated by a 45-minute train ride.[16] In Shenzhen, areas of the city are dedicated to the creative arts in design and have a focus on visual media and prints. The Shenzhen High-Tech Innovation Park as of 2009 had a 50 percent occupancy, with privately owned intellectual property as the underpinning of their business venture.[17] In 2010, Hong Kong and Shenzhen signed a formal exchange agreement to share design and business knowledge. To date, 200 companies in Shenzhen are now working with research and development entities and universities in Hong Kong.

Many other creative and innovation parks are emerging in second- and third-tier cities to support the Chinese government directive. A twelve-year master plan by the Chinese government to move the southern area of Guangdong in the PRD from a manufacturing base to an international creative base is underway. It identifies areas within the region planned for specific expertise: "Foshan will be a manufacturing center for electrical appliances and building materials; Dongguan for clothing; Zhongshan, lighting and Jiangmen, paper."[18] A digital entertainment and innovation park in Guangzhou in the south of China has $100 million U.S. dollars in investment capital for a focus on animation, game development, and post-production in creative media. Wuxi, in central China, hopes to become a design hub for product design.[19]

In Beijing the famous 798 arts area has garnered much attention and attracts visitors who want to see art and design in process, although artists like Ai Weiwei and fashion designer Guo Pei have moved to lesser-known areas. Just outside Hangzhou and close to Shanghai is Phoenix Park, home to many businesses and exhibitions focusing on design and creativity. Shanghai's Shanghai-Zhanjiang Technology and Innovation Park is geared to the development of Chinese patents and tech transfer.[20]

Among the other creative industries parks throughout China are these:

Beijing—Cable 8 New Media Creative Center

D Park—751 Fashion Design Plaza

Chengdu—Red Star 35

Guangzhou—Fuoshan Creative Industries Park

Hangzhou—Loft 49

Hong Kong—Jockey Club Creative Arts Centre

Nanjing—Idea 8

Shanghai—Tian Zi Fang, Bridge 8

Shenzhen—Sphinx Co. Ltd.

These parks are set up to support artists, designers, and entrepreneurs who are working in creative fields. The tenants of some of the parks have group events and invite the public for an open house, or hold art and design marts. The fact that these creative parks are now in every province shows the commitment by the local governments to support the arts and creative entrepreneurs.

Modernizing, the Chinese Way

For centuries China has taken ideas from all over the world; it has used what was valuable to its society and given great ideas to the world in return. Chinese culture is so finely woven that any idea taken into its culture becomes part of the culture itself. In some ways, this is similar to what was called "self-strengthening" in the past, reflecting on what it does well and not so well and taking steps to change. If we look at the adoption of Western technologies such as the Internet, mobile phone, and television, the technology may have been adopted, but the use and programming are Chinese. Jiang, a leading Chinese commentator, believes the next years for China are key for its transition.[21] She identifies six megatrends that will affect China's future:

1. The end of cheap labor
2. Record productivity growth to drive quarterly profits
3. A move from importing to exporting
4. A shifting balance between banks and capital markets
5. Higher agricultural commodity prices
6. Reversing environmental degradation

What this means is rapidly overcoming a steep learning curve for designers in China and those from overseas who are considering working in China. This fast pace is at odds with the incremental change that China is

used to. But this is a thing of the past: government officials have become bold in making changes designed to bring world status to China.

Loyal Clients

Elaine Ann, principal of Kaizor Innovation, based in Hong Kong, is a true pioneer when it comes to design research.[22] She was the first to open a design research firm that conducts work in Hong Kong and mainland China. She was also one of the earliest in China to tell clients how design research can help them make better product designs by understanding what customers want. She said, "Chinese industries need to understand that design requires a lot of 'brain work' and not just drawing." Once she works with a client and they establish a relationship, the company usually becomes a long-term client. These long-term business relationships allow clients to gain a deeper understanding of what design can do for them and helps her to position design research to suit the company.

She also finds a difference working in the East and West. Whereas Chinese clients are loyal, those in the United States are not necessarily so.

Ever insightful, Elaine states: "Even though design in China is on the rise, quality and innovation are not always in agreement. Just as technology or invention does not always result in innovation, it is that extra step called design that can make the difference."

It may seem to Westerners that China is slow to move in some areas. However, the Chinese way is to take stock of the situation, assess with others what is needed, and then move forward with a process in a concerted way.

Investing Time in Understanding China

There is currently a lack of tiered retail outlets and distribution networks in China. It takes time to find where to buy and sell in China and how to distribute through trusted people. However, once relationships are established in China, they can last a lifetime. It is important to share the success of a business, especially if another business has played a role in that success. There may not be monetary payment involved as a way of sharing the success, but there may be a way to drive new business to the other business or share manufacturing, sourcing, or technology knowledge.

China is not constrained by the practices of the West. Lack of labor unions in some industries, partially government owned companies, and in some cases a barter system between companies are only a few of the different practices. It is a tumultuous business environment with an uneven future, but China has some of its own best practices that they have used over the centuries.

China lost an entire generation of business managers during the Cultural Revolution, but the third generation is finding its way forward. This generation is the first since the start of the PRC to have to work and compete to earn a living in a Western-like economy. The pressure on this third generation is similar to the generation in East Berlin that went from communism to capitalism and realized that items such as housing and transportation were expensive once the government was no longer paying.

As the Chinese feel their way forward, these issues are key to understanding them:

• Many ideological movements in China today are not entirely new. Examples are the "first get rich" focus and the opening up of China. Genghis Khan, the Mongol warrior, amassed riches from the greater region. Deng Xiao Ping too realized that money is needed to fuel a successful economy and government.

• The rush for Western products by the newly wealthy may not last. There is a history of the West wanting to sell products to China but China not wanting things from the West. As design matures in China, the Chinese people may prefer their own luxury Chinese products as they did in the past.

• There are many Chinas within China. The five provinces vary greatly in ethnic makeup, geography, prosperity, and natural resources. There will be some homogenization as migrants move among the provinces and spread their local cultures, but it will take a long time for life in the various parts of China to resemble each other. It is not just a matter of one area wanting to have or mimic what the other has; the areas have their own culture, and many want to preserve these differences. Huge geographical differences also impose large cultural differences such as fishing villages near the oceans, minority culture mountain villages, Mongolian pastures, and other areas where the cultures form in relation to their surroundings.

Designing for the Chinese Market

The diversity in the Chinese marketplace can be perceived as an opportunity or a problem. The problem is that most products do not fit all provinces, and they may not sell across China. However, once a product is developed that becomes popular throughout the country, the opportunities are huge. Another advantage of the diversity of the marketplace is that experimentation with products is easier. A smaller investment in a product in a localized market will allow companies, both national and foreign, to test their brand. Choosing a province, studying it to determine what it needs, and designing for it may be the way to enter the market rather than trying to focus on the entire nation.

The following ideas are gleaned from the research conducted for this book and are offered to those interesting in selling in Chinese markets:

• Products can be targeted for the newly emerging classes in China.

• Products can be targeted for the different generations in China.

• The poorer classes and rural populations want well-designed products too.

• In the short term, Western products with Chinese characteristics will be accepted readily.

• In the long term, Chinese products with Western appeal will be easier to export.

• Apartment living determines the design of household objects, furniture, and issues such as delivery and assembly services.

• China is already a "car culture." Consider products related to travel and highway services.

• Anything related to family, children, and education will be of interest.

• Beauty and home health products will be of great interest due to the aging of the population and personal expression.

• Personal development and specialized education will be of great interest to those between twenty and thirty years old who are trying to get ahead.

• Products and media related to personal relationships are of interest because the younger generations are choosing their mates rather than having arranged marriages.

• Enjoying life is an important theme in China, especially for the older and youngest generations. Movies, books, games, sports, and vacations will help the Chinese people to enjoy life, something on which they will be glad to spend their newly found wealth.

The Chinese government's plans for design and innovation are already showing results: China is now third in the world for number of patents granted. The education system is undergoing great change, from a memorization and exams "no-questions-asked" mentality to one of exploration and innovation.

As China continues to change rapidly, it will bring new opportunities for those who take the time to learn about this vast country. China has already made many significant contributions to the rest of the world and will continue to do so. And like the 2008 Beijing Olympics ceremony, it will show beauty and discipline through its modernization.

8 The Fourth Generation

China's fourth generation, those born in the 1980s and 1990s and now in their twenties and teens, are in a quandary. They are exuberant, patriotic, and filled with promise of what their lives will bring, but they are also anxious. They are already competing for everything important for a successful Chinese lifestyle: education, job, salary, life partner, apartment, and transportation. With a focus on education and not much else other than technology, they have difficulty in expanding their world to include relationships and free time. Hungry for new experiences, they try everything from Pleasant Goat bath gel to kissing on the streets of Beijing.

Competition

This heightened competitive environment will be a boon and a problem for China. It is estimated that there are 640 million Chinese under the age of thirty.[1] With these huge numbers of young people competing to be the best, the impact of this will be revealed in the intellectual rise of China. This competition will lead to economic robustness as innovative new products come to market. In contrast, estimates now are that 80 percent of design work is copying and only 20 percent innovation.[2]

These numbers will start to change as the competitive spirit takes over. This spirit will show up in everything from chess matches and sports competitions to wealth and status. But this highly competitive atmosphere may keep corruption and a lack of integrity alive in China as people look for easy ways to succeed.

This supercompetitive generation will expect a lot from the government: uncensored Internet access, a focus on environmental protection, and a fair

shot at owning a home and a car, for example. Although they are patriotic, they believe they should be able to criticize their government freely.

Freedom

Many in this fourth generation have the benefit of education, technology, improved food, better health care, a wide array of products in the home, and transportation. They certainly have more freedom in self-expression through personal appearance than their parents' generation did at their age. They also have the freedom to choose a career, relationships, and whether and where to travel. With increases in salaries will come freedom of choice for a range of experiences. Art, film, literature, music, and popular culture will continue to grow and become major markets in China.

Korean boy bands strike a chord with teens in China, and like young girls all over the world, the boy bands send young girls into tears and giggles. The speculation is that the rather effeminate young men are non-threatening to young Asian girls while allowing them to fantasize for hours on end.[3] When asked why they like Korean boy bands, one teen replied that she liked the honesty of the lyrics and that the bands' cover topics are rarely mentioned in China.[4] Topics such as sexual intimacy or same-sex relationships are still considered taboo by older generations in China. This may lend insight into to why these young women also enjoy Korean soap operas. Chinese and Koreans share some cultural characteristics, but Koreans seem to be more open in explaining their feelings about relationships.[5]

China has not allowed animated games from Korea, Japan, or the United States on the mainland. The government seeks to support home-grown influences in animated games, film, literature, and music. However, many students who have studied in the United States and Europe would like access to the culture in those countries. It may be that as this generation ages and more students go overseas, foreign cultures will be of continuing interest in China.

Lifestyle

The belief that everyone in this generation is pampered is wrong. Many are still struggling in rural households while their parents have gone to work

in factories. Many are now in the factories themselves and are looking for better opportunities.

Life in the city for migrant teenagers is difficult. They are often left on their own and do not go to school. If they are admitted to a school, they are not socially accepted by the more sophisticated students, and peer pressure is intense. The result is that many of these teens drop out and look for work to supplement their parents' incomes or buy some of the things that teens want. Some of them turn to crime, either on their own or through falling in with the wrong crowd. A *China Daily* article stated that "most offenders were between 16 to 18 years old, had been born to migrant workers in Beijing or had moved there with parents."[6] As of this writing, the central government is working with local governments to provide more education and health assistance to migrant workers.

Internet Life

Of China's estimated 420 million Internet users, 60 percent are under thirty years old.[7] Those in their teens and twenties are advising their parents on which TV or mobile phone to buy. They spend hours playing games, to the despair of their parents and teachers, and regularly instant message. Like teenagers elsewhere, they find e-mail too slow and hope to avoid censors with their mobile messages.

Renren, China's own social networking site and answer to Facebook, censors its own site. In Wuhan, 500 staff members review all posts for anything that the government would find sensitive or offensive.[8] The 170 million users "post status updates, share links, upload photos and blog."[9] As of 2011, the top social networking sites in China are Renren, Kaixin, and Bouban. The top video-sharing sites are Youku and Tudou; online trade sites are Taobao and Paipai by Tencent; and the top search engine is Baidu.[10] Facebook, which is banned on the mainland, translates in phonetic Putonghua as "doomed to die."[11] Facebook is strong, however, in other parts of Asia and has offices in the region even though it has no opportunity now in China.

The parents of Chinese teenagers are increasingly concerned about Internet addiction. A Chinese Academy of Social Sciences national survey estimated that there are 33 million teenage Internet addicts.[12] The mainland authorities are requiring antiaddiction measures in the games themselves, whereby players are stopped after five hours a day. No points are earned

after this amount of time spent playing, and for younger children, the time limit is three hours.[13]

Purchasing

In a *South China Morning Post* article on car financing, a consultant from Ipsos said, "These people are very different from their parents' generation. They work hard, play hard and have no qualms about snatching up the latest iPhones or other fancy gadgets on credit."[14] But most Chinese consumers are still using cash. Whereas 80 percent of Americans use loans to purchase cars, only 10 percent of Chinese purchases are made with loans.[15] A young middle manager purchased a car and did not mind paying a bit more for exactly what he wanted, but the best part, he said, was that "he didn't have to borrow from family or friends" to make the purchase.[16]

Apple, which launched its first big store in Beijing in summer 2010, found that China's "mobile phone market . . . is tightly regulated and state-owned companies control service contracts."[17] Apple estimated that over 1 million iPhones had been brought into the country and unlocked for use without their users purchasing a long-term contract. Apple will compete in the Chinese market with familiar names such as Motorola and Nokia and with Chinese-based brands such as Lenovo's LePhone. A state-owned company that was selling iPhones said sales were not as brisk as expected because the Apple product is still too expensive for the majority of mobile phone owners in China.

The Chinese people believe that having and saving money is a virtue. Whether this cultural belief will be demonstrated by those now in their teens and twenties needs to be seen. The one-child policy has provided many of these young people with a seeming abundance of money from parents and grandparents. Friends may also come to the financial rescue. A McKinsey report estimated that "Chinese teens collectively represent a market of about $36 billion a year. Chinese parents, who tend to dote on their kids, spend $28.75 billion on this group's behalf, and $7.5 billion comes directly out of the pockets of the young."[18]

Experiences

Those in the fourth generation crave new experiences, and many of these new experiences come from shopping or using new products. Girls

experiment with fashion, makeup, relationships, and technology, and boys experiment with technology, sports, some fashion, and relationships.

New experiences come in many forms for young Chinese consumers. Opal, a company that has ten years of selling experience on the mainland, obtained a license for the animated character Pleasant Goat. In a few months, over 400,000 bottles of Pleasant Goat bath gel were sold at special counters at a major outlet throughout China.[19] Another company, Goddess, designs attractive high-end slippers and is experimenting with sales on the mainland. The general manager, Zhu, said the concept of wearing high-end indoor shoes was initially foreign to local consumers, but they have caught on and the slippers are selling. Younger consumers, however, prefer flip-flops.[20]

"Fast fashion" is a "phrase taken to mean clothing collections which are designed and manufactured quickly, are affordable and are aimed at mainstream consumers; it is otherwise known as 'throw away' fashion." When Taobao.com started its online store, a national clothing brand called Uniqlo from Japan became one of the top performing stores within 10 days.[21] The close proximity of clothing manufacturers, lower-priced goods, and young Chinese consumers' willingness to experiment with fashion have supported many of the low-priced brands.

Fourth-Generation Trends

It is important to remember that half of China's population resides in rural areas. Although there is a trend toward urbanization in every province, there will always be a rural class. Their lot will most likely improve as China finds ways to help young people in these regions with their education, health care, and family finances.

For urbanized young adults, there seem to be five significant trends:

1. *Competition* This generation must compete for everything if they want to be at the top or even get a good education and find a good job. With so many people honing their skills, it will be harder to get a spot in universities, companies, housing development, child care centers, and government.

2. *Relationships* This generation does not have the experience of relating to a partner. They spend most of their time studying or on the computer, and not with the opposite sex. They will seek to understand what works best for them in maintaining a fulfilling relationship.

3. *Political interest* This generation will become very aware of the range of freedoms that other countries have, and they will be unhappy with the government if they are severely restricted in lifestyle.

4. *Wealth accumulation and status* This younger middle-class generation will strive for the finer things in life. The rural and urban poor will strive for better living standards and status.

5. *Global lifestyle inspired by Europe and the United States* As this generation ages, they will be more open to the U.S. products and lifestyle. They will also begin to understand the richness of the European lifestyle and develop an appreciation for quality products.

What They Want

The fourth generation wants experiences: new products, sights, relationships, art, literature, music, and anything else that will have make them feel they are living a great life. They want a home they can feel comfortable in and enjoy their purchases with friends. The rural and urban poor who still feel marginalized by society will continue to achieve a higher status.

The wealthier urban younger generation will want fun and excitement. In order to achieve better relationships on the job and at home and to understand themselves, they will start to turn to the Chinese self-help literature. The days of turning to Confucian or Mao's philosophies for inspiration in their relationships might be a thing of the past as they look for new ways to be in their new world.

Notes

Series Foreword

1. Herbert Simon, *The Sciences of the Artificial*, 2nd ed. (Cambridge, MA: MIT Press, 1982), 129.

2. Donald Norman "Why Design Education Must Change," *Core77*, November 26, 2010.

3. W. Edwards Deming, *The New Economics for Industry, Government, Education* (Cambridge, MA: MIT Center for Advanced Engineering Study, 1993).

Chapter 1

1. Yan Pei, "Behind the 29th Olympic Opening Ceremony," china.org.cn, August 10, 2008, http://www.china.org.cn/olympics/news/2008-08/10/content_16182023_3 .htm.

2. *Merriam-Webster Dictionary*, 302. For example, those in generation X in the United States were born in the 1960s and 1970s.

3. Vanessa Wong, "China's New Focus on Design," *BusinessWeek*, http://www .businessweek.com/innovate/content/sep2009/id20090930_579320.htm.

4. Sarah Monks, "Our Time to Shine," *South China Morning Post*, September 30, 2009, 16.

5. Author's discussion in Hong Kong with Henry Steiner and a prominent local art dealer, October 12, 2009 His belief was that there is definitely a "Western-centric" attitude toward creativity that does not match with the creative activities in traditional Chinese art.

6. Richard Nisbett, *The Geography of Thought*, 90.

7. Author's discussion with Chinese designers at a conference in Singapore, April 23, 2009 Young Chinese designers from the mainland were discussing their problems

with their clients on the Chinese mainland, and many felt they would never get a chance to design a totally new product, only one that was revised from a former product that sold well.

8. Author's discussion with a Hong Kong shop owner, June 5, 2010 The author has a close working relationship with this leather worker and shop owner and felt he could design his own bags, but the confidence is not there to do so or even risk making a prototype to put on display to see if it would sell.

9. Huifeng He, "Patent Applications Jump by 33pc," *South China Morning Post*, August 11, 2007.

10. Author interview with a senior design professor at Tsinghua in Beijing, 2010. This professor was very candid with criticisms about the manufacturer and brand companies' lack of originality to make new products, in addition to the government not knowing how to stimulate innovation on a wide scale, but added they were formulating plans.

11. Author interview with Yao at Lenovo headquarters in Beijing, 2010. Xin Xinyang was present during the interview when Yao discussed the management at Lenovo and how they were structured in a way to allow for creative product design.

12. Mihalyi Csikszentmihalyi, *Creativity, Flow and the Psychology of Discovery and Invention*, 28.

13. Scott Morton and Charlton Lewis, *China, Its History and Culture,* 29–38.

14. *The World Fact Book, East and South East Asia, China.* Available at https://www.cia .gov/library/publications/the-world-factbook/geos/ch.html.

15. Xing Li, "On the Population Scale of Social Development," *China Daily*, December 18, 2008, 5.

16. *The World Fact Book, East and South East Asia, China.* Available at https://www.cia .gov/library/publications/the-world-factbook/geos/ch.html.

17. Melissa Chiu, *Chinese Contemporary Art.*

18. Hongxing Zhang and Lauren Parker, *China Design Now,* The Victoria and Albert Museum, exhibition catalog (London: V&A Publications, 2004), 82.

19. Ibid., 183.

Chapter 2

1. Scott Morton and Charlton Lewis, *China History and Culture*, 23.

2. Ibid., 8.

3. Ronald Knapp and Kai Yin Lo, *House Home Family*, 180.

4. Morton and Lewis, 32–38.

5. Yong Jin, *Arts in China*, 8.

6. Ibid., 32–33.

7. Yanni Kwok, "Imperial Pride," *South China Morning Post*, July 1, 2007.

8. Sunamita Lim, *Chinese Style*, 45.

9. Morton and Lewis, 77.

10. John H. McDonald, *Tao Te Ching*, 11.

11. Morton and Lewis, 38–39.

12. Jin, 61.

13. Ibid., 42.

14. Ibid., 92–95.

15. Ibid., 129–130.

16. Tara Jenkins, and Karen Pittar, "Lifting the Veil of Time," *Club*, 22.

17. Robert Temple, *The Genius of China*, 188–190.

18. Ibid., 177–181.

19. Morton and Lewis, 120–121.

20. Yong Jin, *Arts in China*, 52.

21. Lim, 33.

22. Wo-Lap Lam, *Classic Chinese Furniture*, 13.

23. Knapp and Lo, 162–164.

24. Ibid., 93.

25. Nicola Doyle, "For Art's Sake?" *South China Morning Post*, 69.

26. Holledge, Dunn, Hunt, Rolnick, and Courtauld, *All China*, 17.

Chapter 3

1. Author interview with YuYu Huang in Beijing, 2010.

2. June Grasso, Jay Corrin, and Michael Kort, *Modernization and Revolution in China*, 29.

3. Ibid., 181.

4. Thailand Creative and Design Center. 2007. Workers with Money Unite, China's Shopping Revolution, 16.

5. Victoria Edison and James Edison, *Cultural Revolution Posters and Memorabilia*, 9.

6. Ibid., 5.

7. Author interview with a Chinese immigrant to the United States, 2009.

8. Thailand Creative, 16.

9. Ibid., 35.

10. Ibid., 17.

11. Edison and Edison,7.

12. Ibid., ii.

13. Ibid., 9.

14. Ibid.,7.

15. Ibid., 25.

16. Thailand Creative, 88.

17. Author interview with Ming Xi Tan, 2009.

18. Pinghue Zhuang, "Significant Progress Made on Women's Rights, Congress Told," *South China Morning Post*, December 9, 2008, 1.

19. Zhang, Hongxing and Lauren Parker. *China Design Now*, 28.

20. June Grasso, Jay Corrin, and Michael Kort, *Modernization and Revolution in China*, 220-223.

21. *South China Morning Post,* 2008, A10.

22. John Naisbitt and Doris Naisbitt, *China's Megatrends*, 122.

23. Ibid., 136.

24. Zhong Hongxing and Lauren Parker, appendix 1.

25. Author interview with Henry Steiner, 2009.

26. Author interview with Xin Xinyang, 2009.

27. Author interview with Freeman Lau in Hong Kong, 2009.

Chapter 4

1. Thailand Creative, "I Am What I Surf," 103.

2. Verna Yu, "Chipping Away at the Wall of Injustice," *South China Morning Post*, April 5, 2010, A10.

3. Tze-wei Ng, "End Hukou System Call Earns Rebuke," *South China Morning Post*, March 6, 2010, A4.

4. June Grasso and Jay Corrin, Michael Kort, *Modernization and Revolution in China*, 225.

5. John Naisbitt and Doris Naisbitt, *China's Megatrends*, 130.

6. Author interview with Tao Huang, Chicago, 2009.

7. Yu, 58.

8. Maureen Fan, "Rural Chinese Families Feel Migration's Strains," *Washington Post*, February 16, 2007, http://www.washingtonpost.com/wp-dyn/content/article/2007/02/17/AR2007021701473.html

9. Stephen Chen, "Third-Generation Kitemaker Keeps Old Craft Alive," *Sunday Morning Post*, December 2, 2009, 6.

10. David Eimer, "Degrees of Guilt," *Post Magazine*, April 5, 2009, 10.

11. Kristine Kwok, "Café," *South China Morning Post*, June 20, 2010, 4.

12. Aizhu Chen, "One Child Policy Spawns Divorces," *South China Morning Post*, December 1, 2007, C1.

13. Lee Woods, "Party Website Opens to Expose Corruption," *South China Morning Post*, May 24, 2009, 9.

14. David Eimer "Degrees of Guilt," *Post Magazine* (April 5, 2009):14–18.

15. Ibid.

16. Xiangwei Wang, "Message to Authorities: Our Text Lives Are Private," *South China Morning Post*, (January 25, 2010): A4.

17. Lauren Parker, *China Design Now*, 20.

18. Naisbitt and Naisbitt, 124.

19. Ibid., 122.

20. Parker, 29.

21. Michael Bond, *The Psychology of the Chinese People*, 8.

22. Steelcase, *Exploring Generation Y China & India,* unpublished report, 2009.

23. Kevin Kwong, "Man about Town," *South China Morning Post*, March 14, 2010, 10.

24. Alister McMillan, "Voice of the People," *South China Sunday Morning Post*, July 8, 2007, 1.

25. Howard French, "Dynamic Young Engines Driving China's Epic Boom," *New York Times*, October 22, 2008, C6.

Chapter 5

1. Pierre Lu, *China's Elite*, 10.

2. Naomi Revnik, "Style Guru to Business Elite and Counterfeiters," *South China Morning Post*, January 4, 2010.

3. Ibid.

4. David Zhong, "Power Dressing," *Financial Times*, June 16, 2007.

5. Le-Min Lim, "Prices for Chinese Art near Level Seen before the Crisis," *South China Morning Post*, April 11, 2010, 15.

6. Vivienne Chow, "Wealthy Mainlanders Push Antique Prices through the Roof," *South China Morning Post*, March 15, 2010, A8.

7. Ibid.

8. Haoting Lu, "O Brothers," *China Business Weekly*, November 24, 2008, 12.

9. Kandy Wong, "Made for China is Luxury Marques's New Mantra," *South China Morning Post*, (April 17, 2010), 1.

10. Ibid.

11. Mark Graham, "Top Tipple," *Discover China*, February 2010, 42.

12. Ibid., 44.

13. Denise Tang, "Tough Decisions on the Menu as the Downturn Hits Fine Dining," *South China Morning Post*, December 21, 2009, 1.

14. Yanfeng Qian, "Hot Hotels," *China Business Weekly*, November 4, 2008, 3.

15. Peter Simpson, "A Bitter Taste in Olive Garden," *South China Morning Post*, January 31, 2010,11.

16. Chiu-chu Tschang, "China Rushes Upmarket," *BusinessWeek*, September 17, 2007, 38.

17. Tsang, 12.

18. "Population Faces Risk of Rebound," *China Daily*, Hong Kong Edition, May 8, 2007.

19. Hu Yuanyuan, "More Chinese Want to Purchase Homes Abroad," *China Daily*, (December 18, 2008), 13.

20. Ibid.

21. Cary Huang, "Political Change Must Come Next," *South China Morning Post*, December 3, 2008, 3.

22. Fiona Tam, "Poor Find They're Better Off Calling Slums Home," *South China Morning Post*, January 16, 2010, 6.

23. Michael Schuman, "Rebalancing Act," *Time*, November 30, 2009, 39.

24. Ibid.

25. Andrew Batson, "China's Inequality Seen Leveling Off," *Wall Street Journal*, February 3, 2010.

26. Stephen Chen, "Mainland Bans Private Websites", *South China Morning Post*, December 15, 2009, A7.

27. Brook Larmer, "Building Wonderland," *Wall Street Journal,* April 6, 2008, 85.

28. Huang, 10.

29. Jack Plunkett, "The U.S. Is Selling More to China Than You Might Think—A Trip to a Beijing Mall, U.S. Brands Are Everywhere" Facebook (February 25, 2010). Available at http://www.facebook.com/notes/plunkett-research.com.

30. Joel Backaler "What Are China's Consumers Eating?" *Forbes* (June 4, 2010). Available at http://blogsforbes.com/china/2010/06/04/.

31. Alisa Gould-Simon, "Leading British Fashion Brands Entice China's Nouveau Riche," June 6, 2010. Available at http://www.guardian.co.uk/world/2010/jun/06/china-fashion-designer-shops.

32. LiAnne Yu, Cynthia Cha, and Chris Ireland, *China's New Culture of Cool*, 58.

33. Aric Chen, *Fast Company*, October 2009, 125–129.

34. Kandy Wong, "Car Firms Face Uphill Drive for Success," *South China Morning Post*, August 27, 2007, 5.

35. Michael Schurman, "Rebalancing Act," *Time*, November 30, 2009, 38.

36. Author's discussion with He Renke, 2009.

Chapter 6

1. Author's interview with YuYu Huang, Beijing, 2010.

2. Author's interview with Cai Jun, Beijing, 2010.

3. Author's interview with Lui Zhen Sheng, Beijing, 2010.

4. Author's interview with Xin Xinyang, Hong Kong, 2009.

5. Author's interview with He Renke, Changsha, 2009.

6. Author's interview with Yao Yingjia, Beijing, 2010.

7. *China Daily* (January 27, 2010), "Guo Pei: Star to the Stars" http://news.cultural-china.com/20100127151839.html.

8. Ma Ke, speech at the Design for Asia Awards, Business of Design Week in Hong Kong, 2008.

9. Author's interview with David Jia, Beijing, 2010.

10. Thailand Creative & Design Center, 2007. *Workers with Money Unite, China's Shopping Revolution.*

11. Author's interview with Zhu Haoyong, Beijing, 2009.

Chapter 7

1. Du Guodong, editor, "Full Text of Hu Jintao's Report at 17th Party Congress," www.chinaview.cn 2007-10-24 21:31:16 http://news.xinhuanet.com/english/2007-10/24/content_6938749.htm.

2. Available at http:// [AU: insert missing info in proof]

3. Bonnie Chen, "Group Fears Triple Whammy May Shut 10,000 HK-Owned Factories," *Standard*, May, 8, 2008, 6.

4. Ibid.

5. Denise Tsang, "Migrant Workers Offered Perks to Return to Work," *South China Morning Post*, February 13, 2010, 1.

6. Michael Rudnick, "Chinese Takeaway," *Home Furnishing News (HFN)*, February 5, 2007, 20.

7. Author's interview with Yao Yingjia, Beijing 2010.

8. Author's interview with John Woo, Beijing 2010.

9. Author's interview with Cathy Huang, Shanghai 2009.

10. Ministry of Education of the People's Republic of China, "Higher Education," http://www.moe.edu.cn/publicfiles/business/htmlfiles/moe/s4971/index.html.

11. Industrial Design Society of America 2008 Member's Directory.

12. Ministry of Education of the People's Republic of China, "Higher Education" http://www.moe.edu.cn/publicfiles/business/htmlfiles/moe/s4971/index.html.

13. Author's interview with Eric Chan, Hong Kong, 2009.

14. Wu Meiling, "Tianjin High-tech Park,"http://www.chinatoday.com.cn/ctenglish/se/txt/2009-03/10/content_184136.htm.

15. Software Industry Park, Ningbo http://www.nbbi.net/doc/cyzt/ljy/.

16. Ibid.

17. Ibid.

18. Chen, 4.

19. Ibid.

20. Xie Fang and Liu Aizhang, "Hangzhou's Old Factories Turn Into Creative Parks," *China Daily*, July 2, 2010. http://www.chinadaily.com.cn/m/hangzhou/e/2010-07/02/content_10050231.htm.

21. Zoran Nedeljkovic, "Enter a Different Dragon," *Net Worth*, September 2007, 22.

22. Author's interview with Elaine Ann, Hong Kong, 2009.

Chapter 8

1. Lianne Yu, Cynthia Cha, and Chris Ireland, *China's New Culture of Cool*, 3.

2. Sophie Yu, "Microsoft Likens China Market to Wild West, *South China Morning Post*, " February 22, 2011, B1.,

3. Chris Berry and Nicola Liscutin, and Jonathan Mackintosh, *Cultural Studies and Cultural Industries in Northeast Asia*, 151–167.

4. Ibid.

5. Ibid.

6. Xie Chuanjiao, "Raising the Issue of China's Troubled Teens," *China Daily*, May 7, 2009, http://www.chinadaily.com.cn/china/2009-05/07/content_7751772.htm.

7. Peter Ford, "China's Slow-Burning Fuse of Youthful Cynicism," *South China Morning Post*, September 19, 2010, 13.

8. Lana Lam, "Social Media Finding Ways around Censors," *South China Morning Post*, February 13, 2011, 1.

9. Ibid.

10. Ibid.

11. Lana Lam, "Facebook Coy on Mainland Plans," *South China Morning Post*, February 13, 2011, 2.

12. Fiona Tam, "Parents Given Control of Child Accounts in Online Addiction Fight," *South China Morning Post*, February 8, 2011, 4.

13. Ibid.

14. "Carmakers Target Vehicle Finance to Drive Growth," *South China Morning Post*, August 19, 2010, B4.

15. Ibid.

16. Ibid.

17. David Barboza, "Opening a Big Store in China, Apple Is Still a Market Underdog," *New York Times,* July 9, 2010, B7.

18. Dexter Roberts, "China's Surprising Teen Consumers," *Businessweek,* July 31, 2006. http://www.businessweek.com/globalbiz/content/jul2006/gb20060731_829548.htm

19. "Creative Hong Kong in Shenyang," *Hong Kong Trade Quarterly,* no. 16 (September 2010): 37.

20. Ibid.

21. Hong Kong Trade Development Council, "The Great Migration," *China's Move to Urbanize,* no. 16 (September 2010): 74.

Bibliography

Berry, Chris and Niclola Liscutin, Jonathan Mackintosh, eds. 2009. *Cultural Studies and Cultural Industries in Northeast Asia*. Hong Kong: Hong Kong University Press.

Bond, Michael Harris, ed. 2008. *The Psychology of the Chinese People*. Hong Kong: Chinese University Press.

Chiu, Melissa. 2008. *Chinese Contemporary Art: Seven Things You Should Know*. New York: AW Asia.

Csikszentmihalyi, Mihaly. 1996. *Creativity, Flow and the Psychology of Discovery and Invention*. New York: HarperCollins.

Edison, Victoria, and James Edison. 2005. *Cultural Revolution Posters and Memorabilia*. Atglen, Pa.: Schiffer.

Fishman, Ted C. 2006. *China Inc*. New York: Scribner.

Grasso, June, Jay Corrin, and Michael Kort. 2009. *Modernization and Revolution in China: From the Opium Wars to the Olympics*. Armonk, NY: M. E. Sharpe.

Grasso, June, Michael Kort, William Tilchin, and John Zawacki. 2007. *Revolutions in Russia and China*. New York: McGraw-Hill.

Haas, Ken, and Henry Steiner, eds. 1995. *Cross-Cultural Design: Communicating in the Global Marketplace*. London: Thames & Hudson.

Knapp, Ronald G., and Kai-Yin Lo, eds. 2005. *House Home Family: Living and Being Chinese*. Honolulu: University of Hawai'i Press.

Lam, Willy Wo-Lap. 2005. *Classic Chinese Furniture*. Hong Kong: FormAsia.

Lim, Sunamita. 2006. *Chinese Style: Living in Beauty and Prosperity*. Layton, Utah: Gibbs Smith.

Lo, Kai-Yin. 1998. *Classical and Vernacular Chinese Furniture in the Living Environment*. Hong Kong: Yungmingtang.

Lu, Pierre. 2008. *China's Elite*. Hoboken, N.J.: Wiley.

McDonald, John, trans. 2009. *Tao Te Ching*. London: Arcturus Publishing.

McGregor, James. 2005. *One Billion Customers*. London: Nicholas Brealey.

Meredith, Robyn. 2007. *The Elephant and the Dragon*. New York: Norton.

Morton, W. Scott, and Charlton M. Lewis. 2005. *China: Its History and Culture*. New York: McGraw-Hill.

Naisbitt, John, and Doris Naisbitt,. 2010. *China's Megatrends: The Eight Pillars of a New Society*. New York: HarperCollins.

Ng, Aik Kwang. 2001. *Why Asians Are Less Creative Than Westerners*. Singapore: Prentice Hall.

Holledge, Simon, Charis Dunn, Jill Hung, Harry Rolnick, and Caroline Courtauld. 1986. *All China*. Lincolnwood, IL: Passport Books.

Nisbett, Richard E. 2003. *The Geography of Thought*. New York: Free Press.

Rapaille, Clotaire. 2006. *The Culture Code*. New York: Broadway Books.

Sinha, Kunal. 2008. *China's Creative Imperative: How Creativity Is Transforming Society and Business in China*. Singapore: Wiley.

Smith, Huston. 1986. *World's Religions*. San Francisco: HarperCollins.

Steelcase. 2009. *Generations in the Workplace*. Unpublished report.

Temple, Robert. 2007. *The Genius of China: 3000 Years of Science, Discovery and Invention*. Rochester, VT: Inner Traditions.

Wang, Xian. 2007. *Creativity in China*. Beijing: China Intercontinental Press.

Yong, Jin. 2007. *Arts in China*. Beijing: China Intercontinental Press.

Yu, LiAnne, Cynthia Cha, and Chris Ireland. *China's New Culture of Cool: Understanding the World's Fastest-Growing Market*. Berkeley: New Riders, 2007.

Zhang, Hongxing, and Lauren Parker. 2008. *China Design Now*. London: V&A Publishing.

Index